FACT INTO FIGURE

FACT INTO FIGURE

Typology in Carlyle, Ruskin, and the Pre-Raphaelite Brotherhood

by

Herbert L. Sussman

Ohio State University Press: Columbus

Copyright © 1979 by the Ohio State University Press
All Rights Reserved.

Library of Congress Cataloguing in Publication Data

Sussman, Herbert L.
 Fact into figure.

 Includes index.
 1. Preraphaelitism—England. 2. Carlyle, Thomas,
1795–1881. 3. Ruskin, John, 1819–1900.
4. Pre-Raphaelite Brotherhood. 5. Aesthetics,
English. I. Title.
N6767.5.P7S9 700'.942 79–12355
ISBN 0–8142–0301–9

To Charlotte and Lucas

CONTENTS

Illustrations

Acknowledgments

Any study of the Pre-Raphaelite Brotherhood must acknowledge those recent works of arduous and admirable scholarship that have, finally, made systematic study of the group possible—William E. Fredeman's *Pre-Raphaelitism: A Bibliocritical Study,* the first work to chart the variety of materials available to scholars; Virginia Surtees's *Paintings and Drawings of Dante Gabriel Rossetti,* the long-needed catalogue raisonné; and the catalogues prepared by Mary Bennett for exhibitions of the work of Holman Hunt and John Millais at the Walker Art Gallery, Liverpool. To these studies, this book is indebted throughout.

I would also like to thank the graduate students in English at Northeastern University and the Harvard Victorians with whom I have discussed portions of this study. There is also a debt to those who helped in the preparation of this manuscript—Susan Kutak, Jacqueline Megna, Debbie Brooks, Alexis Green, and Vicki Casana. And, finally, there is a large measure of thanks for the advice and assistance of Elisabeth Sussman.

For permission to reprint materials that were originally published elsewhere, I wish to thank the *Victorian Newsletter, Victorian Periodicals Newsletter,* and *Victorian Studies* and the Trustees of Indiana University. For permission to quote manuscript material, I wish to thank the Ashmolean Museum, the City of Manchester Art Galleries, and the John Rylands University Library of Manchester.

D&W	Rossetti, William Michael. *Dante Gabriel Rossetti as Designer and Writer*. London: Cassell, 1889.
Fine Art	Rossetti, William Michael. *Fine Art, Chiefly Contemporary*. London: Macmillan, 1867.
Fredeman	Fredeman, William E. *Pre-Raphaelitism: A Bibliocritical Study*. Cambridge, Mass.: Harvard University Press, 1965.
Germ	*The Germ: A Facsimile Reprint*. Ed. William Michael Rossetti. London: Stock, 1901.
Hunt	Hunt, William Holman. *Pre-Raphaelitism and the Pre-Raphaelite Brotherhood*. 2 vols. London: Macmillan, 1905.
Hunt, Walker Catalogue	*William Holman Hunt: Catalogue of an Exhibition Arranged by the Walker Art Gallery*. Liverpool: Walker Art Gallery, 1969.
Letters	*Letters of Dante Gabriel Rossetti*. Ed. Oswald Doughty and J. R. Wahl. 4 vols. Oxford: Clarendon, 1965–67.
Marillier	Marillier, Henry C. *Dante Gabriel Rossetti: An Illustrated Memorial of His Art and Life*. London: Bell, 1899.
Millais, Walker	*Millais: An Exhibition Organized by the Walker Art Gallery Liverpool & the Royal Academy of Art London*. London: Royal Academy, 1967.
PRBJ	*The P. R. B. Journal: William Michael Rossetti's Diary of the Pre-Raphaelite Brotherhood, 1849–1853*. Ed. William E. Fredeman. Oxford: Clarendon, 1975.
RRP	*Ruskin: Rossetti: Preraphaelitism. Papers 1854 to 1862*. Ed. William Michael Rossetti. London: Allen, 1899.
Stephens, *Hunt*	Stephens, Frederic George. *William Holman Hunt and His Works: A Memoir of the Artist's Life with Descriptions of His Pictures*. London: Nisbet, 1860.

Stephens, *DGR*	Stephens, Frederic George. *Dante Gabriel Rossetti*. London: Seeley, 1894.
Surtees	Surtees, Virginia. *The Paintings and Drawings of Dante Gabriel Rossetti (1828–1882): A Catalogue Raisonné*. 2 vols. Oxford: Clarendon, 1971.
Works, DGR	*Works of Dante Gabriel Rossetti*. Ed. William Michael Rossetti. London: Ellis, 1911.

The dates of visual works are indicated parenthetically. "R.A." indicates the date of exhibition at the Royal Academy. For Rossetti, the date is taken from Surtees.

Rossetti's visual art is identified by parenthetical reference to the catalogue number in Surtees; that of Hunt and Millais by reference to catalogue numbers in *Hunt*, Walker Catalogue, and *Millais*, Walker Catalogue.

Introduction

In her charming autobiography, *My Grandmothers and I,* Diana
Holman-Hunt tells of going with her grandmother, the widow
of the painter Holman Hunt, to visit the version of *The Light of the
World* hung in Saint Paul's Cathedral. As a crowd gathered about
the formidable figure of Mrs. Hunt, she proclaimed, "I have the
honour to be the artist's widow. . . . The picture is full of sym-
bols: the white robe represents the Power of the Spirit." But
Diana, who was of a different generation, was of a different
mind concerning the nature of the painter's symbolism. "It was
great-grandma's best damask tablecloth," she tells a boy next to
her. "She was very cross when Grandpa cut it up." And Mrs.
Hunt's reply suggests that even she did not fully share her
husband's sacramental vision: "My grandchild is right in a way
but it was the tailor who cut it up, and in spite of my husband's
careful sketches and entreaties, he produced—what do you
think? A fashionable frockcoat! It was really rather droll."[1]
 Indeed, much in the history of the Pre-Raphaelite Brother-
hood is rather droll. The thought of Elizabeth Siddal freezing in a
tub of cold water while posing as the drowning Ophelia, or of
Holman Hunt, his feet wrapped in straw against the cold, wait-
ing in the freezing night to paint the proper shade of moonlight
on a wall, is so curious to the modern mind that commentators
have often found it difficult to move beyond anecdotal accounts
of the Brotherhood to serious consideration of its principles.
That the Brothers were earnest no one can doubt; indeed, their
earnestness is the very source of their drollness. But that their
curious behavior manifests an aesthetic and a style consistent
within their own terms if not within ours, and that the
Brotherhood's communal enterprise engaged serious issues
within the artistic and literary culture of Victorian England, is a
proposition that is less often accepted.[2]
 One reason for the air of drollness, the attitude of condescen-
sion, that still inform modern accounts of the Brotherhood is the
assumption by many modern critics of an art-historical model
that, with a Hegelian determinism, evaluates nineteenth-
century art according to how closely it anticipates the
"modern."[3] Within this historical scheme, Brotherhood work
comes to be seen merely as a "dead-end" in the evolution of

nineteenth-century art toward impressionism and abstraction. But in the history of the arts there is not cumulative progress but rather the destruction of one paradigm and its replacement by another. The historian of artistic and literary movements can, like the historian of science, seek not to demonstrate how the past failed to anticipate the present but, instead, to reconstruct the coherence of styles and theories that have long since disappeared.[4]

It is precisely because the aesthetic that the members of the Brotherhood shared has disappeared so completely, has become to the modern mind even more remote than the vision of the early-Renaissance artists the Brothers believed they were emulating, that the work of the Brotherhood appears to offer such a striking series of paradoxes. Although adopting an avant-garde role in opposing the teachings of the Royal Academy, the Brothers conceived of their own mission as the restoration of the authentic Western artistic tradition. Attacked intensely by the general periodicals on the exhibition of their early paintings, the Brothers nevertheless saw themselves as public artists, Victorian sages delivering highly orthodox sermons to a wide audience. Furthermore, their effort to emulate Italian artists of the fifteenth century generated a style that in its detailed naturalism and historical accuracy is distinctly of the nineteenth. To the modern sensibility, the virtually obsessive detailing of the physical world works against the transcendental significance[5] and the personal impulses underlying the art against its public meaning.[6] Finally, there is the historical irony that this group so self-consciously devoted to the revitalization of a didactic, orthodox sacramental art should become the germ of the modern movements that developed in later nineteenth-century England. And yet, the communal quality of their activity, the publication of *The Germ* as a manifesto, the stylistic similarities in the work produced by the circle between 1848 and 1853, all indicate that the Brothers themselves did not feel the contradictions so apparent to the modern mind, but rather held to artistic beliefs and to stylistic practices that were so deeply shared as not to require explicit articulation. It is the main purpose of this study to describe these shared ideas and style, to reconstruct the artistic and literary paradigm of the Pre-Raphaelite Brotherhood.

Once the Brothers are no longer forced into the role of precursors, but set within their immediate cultural context, their work emerges not as misguided groping toward modernism but as participation in a widespread effort in the 1830s and 1840s to revive sacramental forms of art and literature through the adap-

tation of figural methods. Like Carlyle and Ruskin, the Brothers sought to reconcile through their art the fading belief in the sacramental quality of the natural world and in the providential nature of history with the powerful new attitudes generated by a wholly materialistic science and an avowedly scientific history. Rather than seeing the visible world as less significant than the transcendent reality that it symbolizes, these Victorians saw both natural fact and historical event as figure, as simultaneously tangible reality and symbol of the transcendent. Within these assumptions, the end of art is neither allegory in the religious sense of leaving the "given to find that which is more real"[7] nor realism in the secular sense of representing tangible phenomena in a world from which God has disappeared. Instead, the Brotherhood, deeply influenced by Carlyle and Ruskin, employed a symbolic realism that sees fact as spiritually radiant and assumes that only through detailed representation of this natural and historical fact can the phenomenal be seen as figuring the transcendent.[8] The highest power of the imagination, then, lies neither in the accurate perception of the phenomenal nor in the unmediated vision of the transcendent, but in the integrated sensibility that can see with the greatest acuity the phenomenal fact while simultaneously reading the fact as sign of a higher reality. At its most successful, figural art depicts the hard, tangible reality of individual lives in historical time while pointing to the providential design that lies beyond history.

Interest in a contemporary version of figural theory developed in the early 1830s with Carlyle's fusion, in such works as "History" (1830), "Biography" (1832), and *Sartor Resartus* (1833–34), of the new historicism with typological reading of Scripture, the most available form of figuralism in Protestant England. By 1843, Carlyle developed in *Past and Present* a literary-historical form adequate to express his vision of the facts of secular history and even of contemporary urban life as manifesting operations of the Divine. In the same year, *Modern Painters* I appeared offering a sacramentalist defense of Turner's landscapes and in 1846 *Modern Painters* II, a work that in its explication of Renaissance religious painting through Protestant typological exegesis exerted the single most important theoretical influence upon the Brotherhood. Indeed, Hunt dates the origin of the Brotherhood to his 1846 conversation with Millais about the possibilities of a truly contemporary, yet distinctly Protestant, religious art based upon the figural principles expressed by Ruskin in *Modern Painters* II (Hunt, 1:90).[9]

But the beginning of 1854 saw the Brotherhood "in its decadence."[10] The divergent imaginative impulses visible in the work of the Brotherhood, but generally subordinated to figural purposes, could no longer be reconciled. Hunt alone continued to create sacramental religious art. Elected an Associate of the Royal Academy in 1853, Millais turned increasingly to the sentimentalism that vitiates his Brotherhood history painting. And Rossetti, obsessively involved with Elizabeth Siddal, moved toward the visionary style that appears in his early illustrations of Dante.

Finally, a note about the boundaries of this study. Throughout, I shall make a distinction between the Pre-Raphaelite Brotherhood, the association of seven young men working together from approximately 1846 to 1853, and the Pre-Raphaelite movement, those artists and writers who followed the Brotherhood and who, for all their variousness of style, felt a common source in the work of the Brotherhood.[11] Since the theory and the style of the Brotherhood differ from that of its followers, the limits of the study are chronological. The focus of this book is the work of the Brothers during the Brotherhood, more particularly, the elements of theory and style shared by the principals of the group—D. G. Rossetti, Hunt, and Millais—during their association from 1846 to 1853. Since for Rossetti, Millais, and, to a lesser extent, Hunt, the Brotherhood marked only a phase in their development, I shall distinguish between their Brotherhood and post-Brotherhood work.

1. Diana Holman-Hunt, *My Grandmothers and I* (New York: Norton, 1961), p. 109.

2. The condescending tone that has disappeared from the discussion of most Victorian subjects lingers on in regard to the Brotherhood. References to the Brotherhood's juvenility and lack of coherent thought are too numerous to cite. I will only quote from two recent popular texts by distinguished scholars. "Like many schools of art, their watchword was the ambiguous 'Back to nature!'—which always turns out to mean something rather different. Painters, sculptors, and critics rallied to the three young founders, and a highly confused non-movement had begun" (Lionel Trilling and Harold Bloom, eds., *The Oxford Anthology of English Literature: Victorian Prose and Poetry* [New York: Oxford University Press, 1973], p. 615). "After a few years, in the manner of such spontaneous and high-minded campaigns, the founders and the associates they had attracted went their separate ways as painters, and such small unity of principle and aim as they had initially had disappeared" (Richard D. Altick, *Victorian People and Ideas* [New York: Norton, 1973], p. 289).

3. For the deterministic view of nineteenth-century architecture as moving toward the International Style, see Sigfried Giedion, *Space, Time, and Architecture*

Introduction

(Cambridge, Mass.: Harvard University Press, 1949). For an influential view of Victorian design as anticipating functionalist theory, see Nikolaus Pevsner, *Pioneers of Modern Design* (New York: Museum of Modern Art, 1949). Even the most intelligent recent criticism of the Brotherhood treats them as precursors; see John Dixon Hunt, *The Pre-Raphaelite Imagination, 1848–1900* (London: Routledge and Kegan Paul, 1968); Morse Peckham, *Victorian Revolutionaries* (New York: Braziller, 1970), chap. 4; Carol Christ, *The Finer Optic: The Aesthetic of Particularity in Victorian Poetry* (New Haven: Yale University Press, 1975), pp. 63–64; Allen Staley, *The Pre-Raphaelite Landscape* (Oxford: Clarendon Press, 1973), pp. 181–85.

4. See the analysis of scientific revolutions by Thomas Kuhn in *The Structure of Scientific Revolutions* (Chicago: University of Chicago Press, 1970).

5. This modernist position is argued by Christ, pp. 57–61.

6. The Pre-Raphaelite use of art to embody personal feelings is discussed by Richard Stein, *The Ritual of Interpretation: The Fine Arts as Literature in Ruskin, Rossetti, and Pater* (Cambridge, Mass.: Harvard University Press, 1975), chaps. 4 and 5.

7. C. S. Lewis, *The Allegory of Love* (Oxford: Oxford University Press, 1968), p. 45.

8. For a provocative discussion of the relationship of transcendentalism and realism in the nineteenth century, see Morse Peckham, *Beyond the Tragic Vision* (New York: Braziller, 1962), chaps. 10, 12, 13.

9. Given the biographical emphasis of Pre-Raphaelite scholarship, this study will not rehearse the often-told story of the founding of the Brotherhood. For a narrative account, see G. H. Fleming, *Rossetti and the Pre-Raphaelite Brotherhood* (London: Rupert Hart-Davis, 1967). For biographical information, see Oswald Doughty, *A Victorian Romantic: Dante Gabriel Rossetti* (London: Oxford University Press, 1960); Diana Holman-Hunt, *My Grandfather, His Wives, and Loves* (London: Hamish Hamilton, 1969); John Guille Millais, *The Life and Letters of Sir John Everett Millais* (New York: Frederick Stokes, 1899), 2 vols.

10. Christina Rossetti, "The P. R. B."

11. These definitions differ somewhat from those of William E. Fredeman in his invaluable book *Pre-Raphaelitism: A Bibliocritical Study*. Fredeman does not see the Brotherhood as having left a "canon of critical comment by which they can be clearly identified" or as having "succeeded in crystallizing their aesthetic assumptions" (pp. 1–2).

FACT INTO FIGURE

Chapter One

VICTORIAN FIGURALISM
CARLYLE AND RUSKIN

 Although the antecedents of sacramental art stretch far back in Western thought, the particular shape of the figuralism adopted by the Pre-Raphaelite Brotherhood derives from two intellectual systems still powerful in early-nineteenth-century England—a pre-Darwinian science closely linked to natural theology and the typological exegesis of Scripture. In each of these modes of thought, the minute investigation of visible fact or historical event becomes the means of strengthening religious belief. In the 1830s and 1840s, both Carlyle and Ruskin, each of whom had studied the Bible at home and science at the university, articulated an aesthetic of the factual in which religious science and typological exegesis become models for the artist's use of a detailed realism to figure the transcendent. It is this identification of the modern artist with the scientist and the elevation of the Scripture read typologically as the model for art that was transmitted, primarily through the writings of Carlyle and Ruskin, to the Pre-Raphaelite Brotherhood.

Pre-Darwinian Science

Although the romantics saw science as so inimical to the imagination that poetry is defined by its opposition to science,[1] for Carlyle, Ruskin, and the Pre-Raphaelite Brotherhood, contemporary science provided a model for the work of the artist. Rather than holding to the Wordsworthian doctrine that we murder to dissect, they believed, with the natural theologians, that the act of dissection, the minute analysis of both animate and inanimate matter, would only further reveal the power and benevolence of God.[2] Within the framework of natural theology, the visible world exists in a richness and vitality that is itself a sign of the power of God. Particularly in the early nineteenth century when an increasing amount of natural detail seemed to be filling in the outlines of the divine plan, the methods of the religious scientist seemed to provide an example for the artist in demonstrating that only through the accurate perception and close recording of physical fact would transcendental purpose be

made clear. In William Paley's *Natural Theology*, a work that Carlyle and Ruskin, as well as most university graduates knew, and that serves in many ways as a model for *Modern Painters* I and II, Paley repeatedly moves to detailed, minute description of physical fact in order to demonstrate the overall purposefulness of the Creation. In describing the circulation of the blood, he notes: "One use of the circulation of the blood (probably amongst other uses) is to distribute nourishment to the different parts of the body. How minute and multiplied the ramifications of the blood vessels, for that purpose, are; and how thickly spread, over at least the superficies of the body, is proved by the single observation, that we cannot prick the point of a pin into the flesh, without drawing blood, i.e. without finding a blood vessel."[3]

The activity of religious science, then, demands a unified sensibility, a mind that is concerned not merely with physical fact and natural law but with fact and law as evidence or sign of divine attributes. For the pre-Darwinian scientist, observation is the support of faith by revealing the faultlessness of the Creation, yet faith is at the same time the support of observation, for the belief that the world is intelligently designed leads the investigator to search for, and to find, the function of each element within this world. Faith becomes even more necessary if physical fact is made to prove not merely the intelligence of the Creator through the economy of the Creation, but the benevolence of the Creator as well. Paley's assertion of the happiness of all created beings, exemplified by the young shrimps' "bounding into the air from the shallow margin of the water" as "signs of their happiness,"[4] seems only wishful thinking to the post-Darwinian mind.

The highest achievement of the religious scientist is a particular kind of work in which the facts and the laws of the natural world are presented in the most minute detail, but in which details and general laws are so organized as to be seen as signs of transcendental truth. The work of Philip Gosse, one of the best-known Victorian religious scientists, exemplifies the belief, shared by the Brotherhood, that acute observation could unveil spiritual truth. In a series of popular books such as *A Year at the Shore* (1865) and *Evenings at the Microscope* (1859), Gosse examines with a truly microscopic eye the living world in order to demonstrate the glory of God. In speaking of the eye of the mollusk called the purple-spotted top, he says:

> If you could dissect out one of these points, and submit it to careful examination with a good microscope, you would find all

[4]

the parts essential to an organ of vision. . . . Minute these parts are, to be sure, but not less exquisitely finished for that. Indeed, the more skill they require in the demonstrator, the more they reflect the inimitable skill of the Creator.[5]

Gosse illustrated these works himself with colored plates done in what might be called a scientific manner. In their hard-edge outline, detailed particularity, definition by color rather than light, clear illumination of each specimen, and closeness of the subject to the front of the picture plane, such drawings as *Dog-Whelk. Pelican's Foot. Top. Cowry* bear a marked resemblance to the work of the Brotherhood. Indeed, when the young Edmund Gosse was taken by his father to see Hunt's *The Finding of the Saviour in the Temple,* he was struck by the correspondence between the Brotherhood manner and scientific illustration: "The exact minute and hard execution of Mr. Hunt was in sympathy with the methods we ourselves were in the habit of using when we painted butterflies and seaweed, placing perfectly pure pigments side by side, without any nonsense about chiaroscuro."[6]

Figural History

Just as a religious science based on the premises of natural theology served, for a time, to reconcile scientific advances with traditional religious beliefs, so figural history attracted interest in the 1830s as a way of fusing the new historicism with an older faith in the providential nature of historical events.[7] In Erich Auerbach's words, the figural reading of history "established a connection between two events or persons, the first of which signifies not only itself but the second, while the second encompasses or fulfills the first. The two poles of the figure are separate in time but both, being real events or figures, are within time, within the stream of historical life."[8] The notion of one historical event as prefiguring another assumes a firmly teleological order, a providential purpose outside historical time yet being fulfilled within it. Furthermore, men still live in figural time. The events of the past figure events occurring in the present or still promised; the events of contemporary life prefigure events to be realized in the future. The historical event as figure, then, is both natural and supernatural, historical fact and transcendent symbol, "both tentative fragmentary reality, and veiled eternal reality."[9]

The mode of figural history that most shaped the sensibilities of Carlyle and Ruskin and that informs Brotherhood painting is the typological reading of Scripture. In its strictest form, typolog-

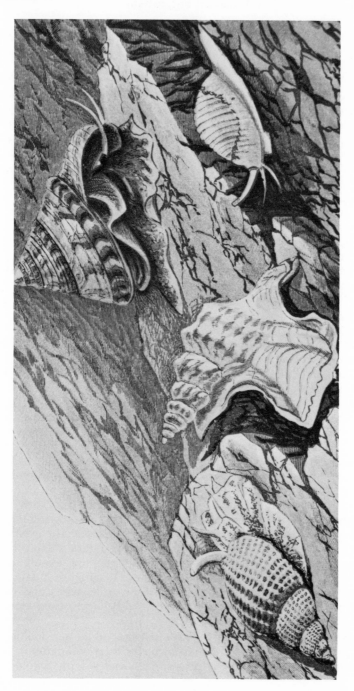

PLATE 1. Philip Gosse, *Dog-Whelk. Pelican's Foot. Top. Cowry.* From *A Year at the Shore* (London: Alexander Strahan, 1865), Frontispiece.

ical exegesis sees a person or event in the Old Testament as a type prefiguring a person or event in the New. Again, the emphasis is on the fusion of historicity and revelation. An event that is real and historical prefigures another event also real and historical within a providential order beyond historical time. Furthermore, the proper reading of the scriptural narrative, indeed, of the entire Book of Human History, demands the same habits of mind as reading the Book of Nature. Within each, not only do events in the phenomenal world have an intense reality but the more intensely and minutely this phenomenal or histori- cal reality is perceived and recorded, the more clearly the tran- scendental is revealed. Just as the more a writer such as Gosse can demonstrate purpose in the smallest detail of the eye of a mollusk, the more powerfully he can demonstrate the intelli- gent design of the Creation, so the more cogently the exegete can demonstrate that the most seemingly inconsequential event in the Old Testament prefigures events in the New, the more clearly he reveals the providential quality of the biblical narra- tive. Furthermore, just as religious science demands a sensibility that unifies faith with acute visual perception, so typological reading of Scripture demands a unified sensibility that perceives the historicity of the events while simultaneously seeing their place in the divine order.

Figural Theory in Carlyle and Ruskin

From their common grounding in typological exegesis and religious science, Carlyle and Ruskin developed an aesthetic in which the facts of nature, of history, even of contemporary life can become through the intensity of their representation radiant with transcendent meaning. Within this view, realism and sym- bolism are not opposed but interdependent. In theory, at least, the more intense the power of observation, the more extensive the awareness of the symbolic meaning; the more accurately each minute fact of the phenomenal world is reproduced, the more forcefully the spiritual significance will shine through. Such an aesthetic depends upon faith in a sacramental universe; and for Ruskin and Carlyle, the term that connects sacramen- talism to the practice of art is the metaphor of art as language, a comparison as suggestive to these Victorian theorists as organic life to the romantics or music to the later Victorians. To the religious scientist, the physical world is itself a form of language, a book written by God that men must decipher. To Carlyle and Ruskin, the more clearly the artist can reproduce this language

[7]

by creating the illusion of confronting the phenomenon directly, the more forcefully the content of this natural language will emerge. For the early Ruskin, the highest example of such an art is, of course, the work of Turner. The fusion of mimetic and religious criteria in Ruskin's defense of Turner's "Truth" provides the background for the sense of sacred mission informing the Brotherhood's own adherence to scientific realism and also helps explain Ruskin's comparison of the Brotherhood to the stylistically opposite work of Turner in his "Pre-Raphaelitism" pamphlet of 1851.

One section of *Modern Painters* I, "Of Truth of Clouds—First of the Region of the Cirrus," will serve as an example. Ruskin speaks of Turner's mimetic accuracy by describing with great verbal precision the appearance of cirrus clouds: "Each rank composed of an infinite number of transverse bars of about the same length, each bar thickest in the middle, and terminating in a traceless vaporous point at each side" (3:359). [10] But to see Ruskin's praise of Turner's Truth as based solely on mimetic grounds is as incomplete as to explain Brotherhood style solely through its opposition to the idealizing manner of the Academy. Like Gosse's drawings of marine life, Turner's work provides scientific data from which the laws governing the natural world become intelligible; Turner's "fidelity and force . . . present us with . . . more clear expression and illustration of natural laws, in every wreath of vapour, than composed the whole stock of heavenly information which lasted Cuyp and Claude their lives" (3:369). As with Gosse, even the discovery of natural laws leads toward, and is subsumed within, a higher and more inclusive form of understanding in revealing what Ruskin calls the "great attributes of the upper cloud region" (3:362). Here the word *attributes* fuses mimesis and revelation by referring directly to the visual appearance of the clouds while simultaneously suggesting that the shape of the clouds is itself a sign of the attributes of the Deity, especially the wisdom of the Creator. Similarly, a phrase like "heavenly information" (3:369) plays upon the double meaning of heavenly to show that through accurate representation of the sky, Turner provides knowledge of a truth beyond the visible world. Turner's mimetic art thus becomes moralized in presenting the natural symbols of hill and sky as clearly and vividly as if the audience were actually present. Ruskin praises "the watchfulness of the entire meaning and system of nature, which fills every part and space of the picture with coincidences of witness, which come out upon us, as they

[8]

would from the reality, more fully and deeply in proportion to the knowledge we possess and the attention we give" (3:367).

To Carlyle and Ruskin, the aim of the artist is to imitate not only the Book of Nature but also the Book of God. For each, art approaches the condition of Scripture. Carlyle's elevation of Scripture into the model for art appears most directly in the influential chapter "Symbols" in *Sartor Resartus*. Here, his distinction between "extrinsic and intrinsic" symbols[11] points to his sense of art as the representation of the sacred significance of fact, rather than the creation of fictions. The "extrinsic," exemplified by political symbols and "other sectarian Costumes and Customs" (223), are inferior in being mere creations of the human imagination. Although through these human constructs there may "glimmer" some transcendent meaning, they lack the "necessary divineness" (223) of the "intrinsic" symbol or figure, the actual phenomenal fact, the creation not of man but of God. In history itself, the noblest such "intrinsic" symbol, the "divinest Symbol" (224), is Jesus, the Word made Flesh, the transcendent manifested in historical time. For the artist-historian, then, the model for art is Scripture itself, the record of this "divinest Symbol," the historically accurate yet spiritually meaningful narrative that Carlyle, anticipating his own chronicling of great men in postbiblical times, calls Jesus' "Biography" (224). It is this sense of the historical reality of Jesus' life, with particular emphasis upon the low economic position and the domestic context, that Carlyle shared with the Brotherhood. In one of Hunt's reconstructed conversations, Carlyle, on a visit to Hunt's studio in 1853, appears to articulate the Pre-Raphaelite vision of a humanized, rather than idealized, Jesus:

> I'd thankfully give one third of all the little store of money saved for my wife and old age, for a veritable contemporary representation of Jesus Christ, showing Him as He walked about. . . . And when I look, I say, "Thank you, Mr. Da Vinci," "Thank you, Mr. Michael Angelo," "Thank you, Mr. Raffaelle, that may be your idea of Jesus Christ, but I've another of my own which I very much prefer." I see the Man toiling along in the hot sun, at times in the cold wind, going long stages, tired, hungry often and footsore, drinking at the spring, eating by the way, His rough and patched clothes bedraggled and covered with dust, imparting blessings to others which no human power . . . was strong enough to give to Him. (Hunt, 1:356–58.)

For Carlyle, as for Ruskin, not only biblical but postbiblical history must be understood and represented in the mode of Scripture. To Carlyle, all human history is a "Prophetic Manu-

script" ("On History," 27:90), a "Divine Scripture" ("On History Again," 28:176), a "Gospel" ("Johnson," 28:110), a "Volume" that some "new Noah's Deluge" may conclude ("Biography," 28:47).[12] History writing, and by extension history painting, then, must emulate the Bible in its concern with the truth of the past. More than Ruskin and more than any of the Brothers, Carlyle finds the very realization of the actuality of the past, an experience often described in religiously resonant metaphors of the unveiling of intense light, as in itself a form of revelation. Of Boswell's *Life*, he says, "How indelible and magically bright does many a little *Reality* dwell in our remembrance!" ("Biography," 28:55). Or he describes how in reading the account in Clarendon's *History of the Rebellion* of the defeated Charles being fed by a peasant, the awareness of the reality of this "genuine flesh-and-blood Rustic of the year 1651" generated a visionary moment in which the "blanket of the *Night* is rent asunder, so that we behold and see, and then closes over him—forever" ("Biography," 28:55). But such evocation of the tangibility of the past becomes for Carlyle in *Past and Present,* as for Ruskin in *The Stones of Venice,* part of a larger plan in which events after the time of Christ are seen as continuing scriptural patterns and even contemporary life is seen as figuring a divinely ordained future. It is the extension of scriptural form, in the sense of establishing historicity through quotidian detail and the arranging of such detail into prefigurative patterns, that is continued in the sacramental symbolism of Brotherhood history painting, such as Hunt's *Converted British Family* (R.A., 1850) (plate 12), and in moralized genre painting, such as Rossetti's *Found* (no. 64) (plate 17).

For Ruskin, too, the Scripture considered typologically is the exemplar of art.[13] At the heart of Ruskin's aesthetic lies the belief in an integrated mode of perception, what might be called a figural sensibility, that can focus on the natural fact while simultaneously comprehending this fact as sign of transcendent power. In his most important definition of this moralized vision, the discussion of the Theoretic Faculty in *Modern Painters* II, Ruskin likens this faculty of the artist to the ability of the exegete to read the Bible typologically, to perceive the spiritual significance within historical fact: "All things may be elevated by affection, as the spikenard of Mary, and in the Song of Solomon the myrrh upon the handles of the lock, and the sense of Isaac of the field-fragrance upon his son" (4:48). It is Ruskin's insistence in *Modern Painters* II that through the re-creation of this Theoretic Faculty the contemporary artist could again create a sacred art,

particularly through historical treatment of Scripture, that provides the most direct link between the figural theory of the 1830s and 1840s and the work of the Brotherhood. For at its inception, the dominant aim of the Brotherhood was the revitalization of what it called "Christian Art" (*PRBJ*, 9) through historically accurate handling of scriptural subjects, and here the chief theoretical source appears to have been Ruskin's discussion of the "Imagination Penetrative" in *Modern Painters* II.

Ruskin defines the Imagination Penetrative, the "penetrating possession-taking faculty . . . the highest intellectual power of man" (4:251), as the ability to perceive and to communicate the transcendent meaning inhering in natural and historical fact. Like Carlyle, Ruskin uses metaphors of discovered light to suggest the artist's revelation of the divine energy contained within the phenomenal world: "Such is always the mode in which the highest imaginative faculty seizes its materials. It never stops at crusts or ashes, or outward images of any kind, it ploughs them all aside, and plunges into the very central fiery heart, nothing else will content its spirituality" (4:250). In his scriptural paintings, then, Tintoretto becomes exemplary in showing the spiritual meaning inherent in tangible historical fact. In the *Annunciation*, Ruskin singles out the setting in a ruined palace and the inclusion of Joseph's carpentry tools, noting that a viewer of secular sensibility would see merely the historical denotation of these tools, responding to them only as a "coarse explanation of the calling and the condition of the husband of Mary" (4:264). But a viewer of Theoretic or figural sensibility would recognize their truly "typical character" (4:265). Seeing the painting with a mind that integrates formalistic sensitivity, acute attention to detail, and religious faith,

> he will find the whole symmetry of it depending on a narrow line of light, the edge of a carpenter's square, which connects these unused tools with an object at the top of the brickwork, a white stone, four square, the corner-stone of the old edifice, the base of its supporting column. This, I think, sufficiently explains the typical character of the whole. The ruined house is the Jewish dispensation; that obscurely arising in the dawning of the sky is the Christian; but the corner-stone of the old building remains, though the builders' tools lie idle beside it, and the stone which the builders refused is become the Headstone of the Corner. (4:265)

Similarly, in praising Tintoretto's *Crucifixion*, Ruskin sees as its "master-stroke" the man, in the shadow behind the Cross, riding on an ass colt and looking "back to the multitude, while he points with a rod to the Christ crucified. The ass is feeding on the

remnants of *withered palm-leaves"* (4:271). To Ruskin's exegetical sensibility, this rather ordinary yet historically possible event figures the "disappointed pride" (4:271) of the Jews when Christ earlier entered Jerusalem riding an ass and carrying palm leaves.

To Ruskin, even the most seemingly inconsequential objects in the painting operate, like the events of Scripture, as types; real and tangible, historically consistent, they figure events in historical time. In the work of Tintoretto, then, Ruskin sees an "illustration of the peculiar power of the imagination over the feelings of the spectator, by the elevation into dignity and meaning of the smallest accessory circumstances." He continues: "But I have not yet sufficiently dwelt on the fact from which this power arises, the absolute truth of statement of the central fact as it was, or must have been. Without this truth, this awful first moving principle, all direction of the feelings is useless" (4:271–72). For Ruskin, as for Carlyle and the Brotherhood, then, the defining quality of effective religious art is the revelation of the sacred meaning within historical fact, "fact as it was, or must have been."

1. Meyer Abrams, *The Mirror and the Lamp* (New York: Norton, 1958), chap. 11.

2. For a discussion of early Victorian science, see Charles Coulston Gillispie, *Genesis and Geology: A Study in the Relations of Scientific Thought, Natural Theology, and Social Opinion in Great Britain, 1790–1850* (New York: Harper & Bros., 1959).

3. William Paley, *Natural Theology: or, Evidences of the Existence and Attributes of the Deity Collected from the Appearances of Nature* (London: R. Faulder, 1803), p. 176.

4. Paley, chap. 26, p. 492.

5. *A Year at the Shore* (London: Strahan, 1865), p. 10.

6. Edmund Gosse, *Father and Son* (New York: Norton, 1963), p. 184. The passage is noted by Jerome Buckley in *The Pre-Raphaelites* (New York: Modern Library, 1968), pp. xvi-xvii.

7. The term *historicism* has acquired many meanings. In this study, I shall use the term to refer to the widespread faith in the early nineteenth century that the past could be reconstructed as it actually occurred and that this re-creation involved an act of imaginative empathy similar to that of the romantic artist, yet an empathy that must be controlled by a scientist's regard for factual evidence. See Hans Meyerhoff, *The Philosophy of History in Our Time* (New York: Doubleday, 1959), pp. 9–18.

8. Erich Auerbach, "Figura," in *Scenes from the Drama of European Literature* (New York: Meridian, 1959), p. 53.

9. Auerbach, pp. 59–60.

10. Citations of Ruskin will refer to *Works of John Ruskin*, ed. E. T. Cook and Alexander Wedderburn, 39 vols. (London: George Allen, 1903–12), and be given parenthetically in the text.

11. *Sartor Resartus,* ed. Charles Frederick Harrold (New York: Odyssey, 1937), p. 222. For convenience, citations of *Sartor* will refer to this standard edition and appear in parentheses in the text.

12. Citations of Carlyle's essays will refer to *Works of Thomas Carlyle,* ed. H. D. Traill, 30 vols. (London: Chapman and Hall, 1896–99), and be given in parentheses in the text. Citations will provide the name of the essay.

13. This discussion follows the same lines as George Landow, *The Aesthetic and Critical Theories of John Ruskin* (Princeton: Princeton University Press, 1971), in pointing to the importance of typological exegesis in Ruskin's work. My own study grows from ideas about the role of typology in both Ruskin and the Pre-Raphaelites that are described in "Hunt, Ruskin and *The Scapegoat,*" *Victorian Studies* 12 (1968): 83–90.

FIGURAL STYLE IN CARLYLE AND RUSKIN
PAST AND PRESENT AND *THE STONES OF VENICE*

 Carlyle and Ruskin, as well as the Brother-hood, seek an art that appears to be not fiction but fact. Working as historian, the figural artist strives to re-create the actuality of the past —the lives of English monks, the worship of men in rude chapels by the Adriatic, daily work in a Galilean carpenter's shop. In treating con-temporary life, the artist focuses on everyday "low" subjects —men lounging in the Piazza San Marco, a confrontation in a Stockport cellar, a prostitute huddled against a London wall. Even scenes from imaginative literature, from Keats or Shake-speare, are presented by the Brotherhood as if they had occurred in historical time. From this desire for a documentary form emerges the most striking quality of this style, its wealth of minutely observed physical detail. To an audience accustomed to the scientific writing and drawing exemplified by Gosse, such a style enforces the sense that the artist is reproducing an actual specimen. The more the work departs from the idealization of the Grand Style or the abstractness of eighteenth-century poetry to include the visible detail that clusters about any event in "real life," the more it appears to be a direct record rather than a fiction.

But attention to detail cannot, in itself, suggest transcendental significance; the intrinsic symbolic meaning of a London street scene or a ruined chapel in Venice cannot be made evident simply through accumulation of closely observed fact. Although Ruskin praised the Brotherhood in his "Pre-Raphaelitism" pamphlet of 1851 for following his advice in *Modern Painters* I that the "young" artist "penetrate" nature's meaning by going to her "rejecting nothing, selecting nothing, and scorning nothing" (12:339), he, as well as Carlyle and the Brotherhood, practiced an art in which the chief, but unacknowledged, formal principle is the shaping of fact into formal parallels with traditional iconog-raphy. Only through such associations can the artist indicate the sacred meaning within the events of biblical as well as postbibli-cal history. Thus, Carlyle suggests providential meaning in the industrialization of England through a prefigurative pattern evoking the Second Coming; Ruskin presents the history of

Venice as a divine example through a similarly prefigurative parallel to the Fall and expulsion from Eden. Similarly, the reconstruction of a Palestinian carpenter's shop, the hut of a druid sheltering a Christian missionary, or Dante's room in Florence acquire significance through such reference to a public symbolic system.

Past and Present as Figural History

In *Past and Present*, Carlyle most nearly realizes the high aim of the artist-historian set forth in the theoretical essays of the 1830s, the representation of the past, particularly the English past, in the mode of the biblical narrative.[1] *Past and Present* is figural history; the persons and events are types prefiguring later occurrences in historical time while this connection within history is seen as evidence of a providential plan outside time. Although the book uses the contemporary literary fashion of historical "contrasts" to criticize the present by setting it against an ideal in the past,[2] the figural method softens the attack on the industrial present. The Middle Ages, seen with a historical sensibility, becomes an imperfect world; the imperfect "Phenomena"[3] of the industrial present become meaningful in prefiguring the perfected industrialism of the future. Unlike *The Stones of Venice*, which gives significance to the fallen present through reference to an earlier Edenic world, Carlyle's book seeks to give meaning to history by constant reference to an end. Indeed, the book might more accurately have been called "Past, Present, and Future" since English history and contemporary life become significant in providing types of future events in the continuum of history.

The subject matter of the book is confined to "historical Fact" (51); the entire action occurs in historical time. With his intense historical empathy, Carlyle enters the past, feels and conveys the hard, tangible actuality of the Middle Ages. Samson struggles against drunken monks and rapacious kings, against shortages of ready cash and political factionalism. His victory, his creation of order from chaos within this one microcosm is shown as analogous to the work of God the Creator, but it is not only a hard-won but a transitory victory. Undoubtedly, Samson is a hero, an exemplar of the virtues of authoritarian rule, yet neither Samson's society nor his community is offered as an ideal to which present society can and should return. The Abbot's community is seen with Victorian historical relativism as adequate for its own day, yet necessarily limited by the consciousness

of the time and therefore impossible to adopt wholly in the present. Samson is treated with the sympathy given to a figure of the Old Testament like Moses, who works within his own limited dispensation, yet whose significance lies in prefiguring a perfected order.

If the past is seen as fallen, the present is perhaps more imperfect. Populated by antitypes, devoted to the false "Gospel of Mammonism" or "Gospel of Dilettantism," its emblem is the pope, the Antichrist, the "Supreme Priest" (141) who has become only a "stuffed . . . figure" (140). Yet these phenomena of the present, like those of the past, achieve significance as prefigurations. Plugson of Undershot, in particular, appears as a type; anticipated by Abbot Samson, he reveals in yet imperfect ways the virtues of the future savior, the Captain of Industry.

Events of past and present prefigure the future that Carlyle has read from the "Bible of Universal History" (240). The final section, book four, "Horoscope," then becomes a New Testament in which is revealed what was foreshadowed in the earlier sections, which become, quite explicitly, analogues of the Old Testament. Abbot Samson is clearly identified as a type, just as the biblical Samson is seen as a type of Christ in the New Testament (Luke 1:15, 2:40). The new "elect of the world" are to be "liberatory Samsons of this poor world: whom the poor Delilah-world will not always shear of their strength and eyesight, and set to grind in darkness at *its* poor gin-wheel" (286). The new savior, the Captain of Industry, is described in terms that make him indistinguishable from Christ: "He walks among men; loves men, with inexpressible soft pity,—as they *cannot* love him: but his soul dwells in solitude, in the uttermost parts of Creation" (287). In these final sections, the gospel of history and the sacred Gospel merge: "*Canst* thou read in the New Testament at all? The Highest Man of Genius, knowest thou him; Godlike and a God to this?" (288).

For Carlyle, the figural vision reinforces the formal necessity of establishing and conveying a sense of historicity. In his effort as historian to reproduce the phenomena of the past as they actually occurred from such shattered evidence as the ruins of Saint Edmund's monastery, Carlyle compares himself to the early-Victorian geologist who from "the old osseous fragment, a broken blackened shin-bone of the old dead Ages," reconstructs the "once gigantic Life lies buried there" (54), restores to modern sight the "extinct species" (49).

Yet Carlyle's sense of himself as artist-scientist or, to coin a Carlylean phrase, as working in a manner "artistical-scientific-

historical," only enforces the connection between realism and moral purpose. The intense feeling of actually entering the past increases the religious power in reinforcing the thoroughgoing analogy to Scripture, in showing the events to be as historical as those of the biblical narrative. And the events themselves acquire prophetic power as being not fictions but intrinsic symbols, examples of "Divine Providence and his Sermon [in] the inflexible Course of Things" (290).

Like such history paintings of the Brotherhood as Hunt's *Converted British Family* (plate 12), *Past and Present* creates the sense of historicity by ordering the work so that the audience is made to feel actually present at the historical event, so that the scene is made visible to "the very eyesight, palpable to the very fingers" (50). As narrator, Carlyle often becomes one with Jocelin by having his voice dissolve into that of the monk. The chapter entitled "Twelfth Century" opens with what is made to appear a direct quotation from the chronicle, in the voice of Jocelin describing ongoing action as seen by a contemporary: "Our Abbot being dead, the *Dominus Rex*, Henry II, or Ranulf de Glanvill *Justiciarius* of England for him, set Inspectors or Custodiars over us;—not in any breathless haste to appoint a new Abbot, our revenues coming into his own *Scaccarium*, or royal Exchequer, in the meanwhile" (68). Only the gloss on Custodiars and Scaccarium betrays the voice of the historian in the present. This melding of the chronicle into the text, this undifferentiated inclusion of the actual perceptions of the participant, is as close as Carlyle could come verbally to reproducing scenes as they actually occurred. And these representations of the perception of a witness in the past, untempered by the present, is the verbal equivalent of the filling of the canvas with what the painter feels are archeologically correct objects, such as the corn and fish nets in Hunt's *Converted British Family*.

For Carlyle, the past is part of a continuum stretching toward an end, yet simultaneously a reflection of the eternal present. As he states in this same chapter on the "Twelfth Century," "Time was, Time is, as Friar Bacon's Brass Head remarked; and withal Time will be. There are three Tenses, *Tempora*, or Times; and there is one Eternity" (68). Showing the relation of these three "Tenses" to the one Eternity is the task of Carlyle as artist and, in combining his two roles of scientific historian and biblical exegete, his method moves toward the pictorial. Like a Brotherhood painter, with archeological accuracy he re-creates the visible scene and through parallels to traditional symbols and later historical events relates the static visual event to the future and

to eternity. In "Twelfth Century," he exclaims, "What a histori-
cal picture, glowing visible. . . . The image of these justly of-
fended old women, in their old wool costumes, with their angry
features, and spindles brandished, lives forever in the historical
memory" (69–70). Carlyle's "historical memory," his empathy
for the past enables him brilliantly to imagine and re-create in
visible terms this tangible scene. But he also establishes a
system of verbal parallels to keep his historical insight within
an Augustinian sense of history. In the same paragraph, the
"image" of these women is shown as a parallel to the political
events of the present. They "become Female Chartists . . . and
in old Saxon, as we in modern, would fain demand some
Five-point Charter" (69). Again, it must be emphasized that
these parallels are not only secular comparisons; they are also
meant to point to a providential order. The way in which the
disorder of the scolding women brought a more beneficent
rule—"Wise Lord Abbots, hearing of such phenomena, did in
time abolish or commute the reap-penny" (69–70)—prefigures
the way in which the disorder of the Chartists will in the present
time bring forth the Christ-like reign of the Captain of Industry.

The paragraph is also pictorial in being arranged in a spatial
rather than chronological order. The sentence explaining the
modern parallel to Chartism precedes the establishing of the
"image of the justly offended old women" (70). The parallels
themselves ("in old Saxon, as we in modern") are expressed in
coordinate construction in which the clause order could be re-
versed without a change in meaning. With past and present
presented as coextensive, the event is pictured in its detailed
historical actuality and as illuminated by divine purpose; it is "a
historical picture, glowing visible."

The chapter "St. Edmund" exemplifies Carlyle's pictorialism.
The central event of the chapter is the disinterring of Saint
Edmund's body by Samson, a scene that finds a visual analogue
in Millais's *The Disentombment of Queen Matilda* (1849). Carlyle's
method is thoroughly visual: "Let the modern eye look earnestly
on that old midnight hour in St. Edmundsbury Church" (122).
To depict the scene itself, Carlyle gives the words of the chroni-
cle, translated "with all the fidelity" (122) he can; the representa-
tion of the past event through the observations of a participant is
as close as Carlyle can come to reproducing the event itself.
Millais's drawing provides a characteristically crowded and
clearly illuminated scene in which the onrush of the citizens on
the right is shown as touching off hysteria within the orderly
ranks of nuns on the left. Carlyle, equally attracted to the emo-

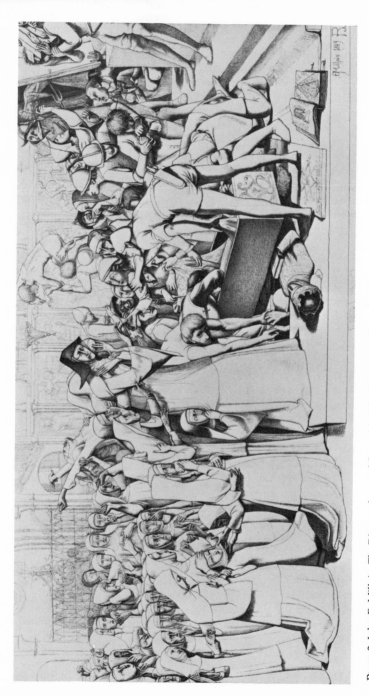

PLATE 2. John E. Millais, *The Disentombment of Queen Matilda*. The Tate Gallery, London.

tional intensity of communal life in the past, provides a more composed, chiaroscuro picture with the illumination at the orderly center occupied by Samson and the frenzied spectators put at the periphery: "What a scene; shining luminous effulgent, as the lamps of St. Edmund do, through the dark Night; John of Dice, with vestrymen, clambering on the roof to look through; the Convent all asleep, and the Earth all asleep" (125). Here, "shining luminous effulgent. . . through the dark Night" refers both to the chiaroscuro appearance of the actual setting and to its noumenous quality, to the transcendent irradiating the phenomenal. Even a phrase like "the Earth all asleep" describes both the night scene as well as the providential historical process in which the new authoritarian society led by the Captain of Industry is already immanent in this true worship of heroes being figured by Samson.

Carlyle, like the Brotherhood, applied this figuralism to events of the present as well as of the past. In *Past and Present*, he sees himself as a modern-day Dante (8,206) moving through contemporary England. Like Ruskin, he finds most congenial the persona of a guide confronting an audience with visible fact while discoursing on its symbolic meaning. In taking the reader through the "Dante's Hell" (8) of modern England, he fastens upon an actual event, reported in the *Times*, in which parents poisoned their children in order to get money from the burial society. As usual, he takes the event, holds it, dwells upon it as a biblical commentator might to explicate its significance: "It is an incident worth lingering on" (9). The scene is represented pictorially as Carlyle with his marvelous empathic imagination enters into the lives and minds of these people as he does into the world of the medieval monastery: "What shall we do to escape starvation? We are sunk here, in our dark cellar; and help is far" (10).

But the scene goes beyond simple realism. Like the Brotherhood and like George Eliot, Carlyle violates decorum to show "high" moral significance in the facts of "low" life. Through a parallel to Dante, the anguish of a starving family of industrial workers is equated with the tragedy of persons in high station: "Yes, in the Ugolino Hunger-tower stern things happen; best-loved little Gaddo fallen dead on his Father's knees" (10). The biblical reference also ennobles the poor, but, in addition, reasserts the providential purpose within this contemporary event: "In starved sieged cities, in the uttermost doomed ruin of old Jerusalem fallen under the wrath of God, it was prophesied and said, 'The hands of the pitiful women have sodden their own children'" (10). As the horrors of the present are "prophesied"

in Lamentations, so, within the scriptural form of the book, the present must be seen, like the events of the Old Testament, to prefigure the coming of a perfected society.

In representing the Stockport cellar as figure, Carlyle's formal difficulties arise from the consecutiveness of language, which prevents any writer from fully representing the simultaneous perception of visual detail and divine meaning. The reference to Lamentations necessarily follows the pictured scene as a separate commentary. Furthermore, the daily events reported in the *Times*, like those in Jocelin's chronicle, do not have the associative meaning acquired over centuries that biblical events do, a meaning so deeply embodied that it is conveyed with the representation of the event itself. Carlyle thus offers a clearly realized contemporary scene accompanied by a biblical gloss, the same form used by the Brotherhood artists in moralized treatments of contemporary life such as *Found*.

In treating contemporary life, Carlyle's figural sensibility moves him to concentrate meaning within the humblest, most ordinary detail. Although he lacks the lingering, painterly attention to visual detail of Ruskin, his transformations of daily events into symbols of urban, capitalist England remain the most memorable portions of the book. In the chapter "Phenomena," the "great Hat seven-feet high, which now perambulates London Streets" is the "culminating and returning point, to which English Puffery has been observed to reach!" (144). In describing the Irish widow, Carlyle first creates a visible scene: "The forlorn Irish Widow applies to her fellow-creatures, as if saying, 'Behold I am sinking, bare of help: ye must help me! I am your sister, bone of your bone; one God made us: ye must help me!'" (151). He then leaps to the symbolic meaning of the pictured event: "She proves her sisterhood; her typhus-fever kills *them*: they actually were her brothers, though denying it! Had man ever to go lower for a proof?" (151).

Within the scriptural scheme, these Victorian facts, the "great Hat" and the Irish widow are intended as types that, as examples of shoddy labor and atomistic isolation, prefigure in their imperfect form the sacramentalized work and communal ties that will emerge in the new industrial society. "I anticipate light *in* the Human Chaos, glimmering, shining more and more. . . . Competition, at railway-speed, in all branches of commerce and work will then abate:—good felt-hats for the head, in every sense, instead of seven-feet lath-and-plaster hats on wheels, will then be discoverable!" (267–68). But rather than revelations of the divine, the "great Hat," the Irish widow, the "amphibious

Pope" (141) emerge as particularized signs of the qualities of contemporary society. Although he employs a religiously suggestive vocabulary, the connection of fact to the noumenous is seriously strained. The Irish widow "proves her sisterhood" by infecting her neighbors, but the force of the passage points less to the mystical unity of humanity than to the atomistic selfishness of capitalist society. The "Hatter in the Strand" sends out his advertising "hoping to be saved thereby" (144), yet the glimpse of urban life is memorable not as an antitype of true salvation but as the emblem of the commercialization of craft. In these passages, the imaginative energy in the particularized description of contemporary life and the clear connection of event to social and economic causes overwhelms the religious resonance of the language.

It demands an intense act of faith to see unemployment, poverty, even starvation not as indicating contradictions within the present society but as prefiguring the perfected future toward which providential history moves. To Carlyle, the Irish widow "proves her sisterhood" (151) by dying; even the pope "has in him more good latent than he is himself aware of" (141). The figural method provides Carlyle with a spiritually resonant means of expressing his deep attraction to industrialism while still calling attention to the life-denying qualities of the present: "Sooty Manchester,—it too is built on the infinite Abysses; overspanned by the skyey Firmaments; and there is birth in it, and death in it;—and it is every whit as wonderful, as fearful, unimaginable, as the oldest Salem or Prophetic City" (227).

This complex attitude toward industrial capitalism, critical yet confident of its future perfection, is expressed through a series of prefigurations of the future savior, the Captain of Industry. Like Abbot Samson in the past, Plugson of Undershot is intended as a type of the future hero of industrialism. Fusing the biblical model with the Victorian sense of historical development, Carlyle shows Plugson as existing in a continuum with William the Conqueror (193) and with "Howel Davies," a seventeenth-century English "Bucanier" who "dyes the West Indian Seas with blood, piles his decks with plunder; approves himself the expertest Seaman, the daringest Seafighter" (192). By showing Davies as a prefiguration of the contemporary millowner and the contemporary millowner as a prefiguration of the future Captain of Industry, Carlyle can not only criticize what he sees as industrial piracy in his own era but, at the same time, also express admiration for the energy and aggressiveness of the industrialist. Like Davies, Plugson is praised as a fighter. "He enlisted

[23]

his thousand men; said to them, 'Come, brothers, let us have a dash at Cotton'" (193). This combativeness shown by Davies and Plugson will, for Carlyle, be moralized by the Captain of Industry: "Captains of Industry are the . . . true Fighters against Chaos, Necessity and the Devils and Jotuns" (268). And this fusion of energy and moral purpose in the future has itself been prefigured in the past: "Yet even of Fighting, in religious Abbot Samson's days, see what a Feudalism there had grown,—a 'glorious Chivalry,' much besung down to the present day" (191).

Plugson is meant to demonstrate the providential pattern of history, yet, by definition, he is not a figure. Unlike the Stockport parents, the Irish widow, or Abbot Samson, he is not based upon a specific historical person but upon Carlyle's own generalized representation of the Victorian millowner. Although based upon observations of contemporary life, Plugson is a fiction, much like his derivative, Josiah Bounderby of Coketown. This formal inconsistency, this unacknowledged departure from figuralism, with the consequent weakening of imaginative power, arises primarily because the facts of industrial life in England did not provide "intrinsic" symbols for the spiritual meaning that Carlyle desired. The "Phenomena" of the present did much to demonstrate oppression, but little to figure the coming moralization of the industrial system.

The dissolution of the figural scheme becomes even more apparent in book four, "Horoscope," the description of the future. Old Testament events become meaningful through their demonstrated fulfillment by other events in history; Moses is a type because of the Incarnation. Within the overall scheme of the book, Plugson, the pope, the entire industrial present of England are meant to reveal the divine because of an event that is to come, the emergence of the saviour who will moralize capitalism. But this savior has not arrived. Ultimately, Carlyle's endowing of contemporary events with religious meaning depends not on demonstration but on a faith that providence works through all events in all time, in the present as in the biblical past, and that within providential history the new leader will be sent to knit the chaos of industrialism into organic filaments. As in the prose of Ruskin and the art of the Brotherhood, the divine quality of accurately depicted fact depends upon a prior faith, a religious sensibility that must be shared by artist and audience. But once this religious vision dissolves, the art takes a wholly new, wholly secular form; *Past and Present* becomes meaningful not in its revelation of historical fact

as figure but in its representation of fact as social symbol revealing in the concrete instance the ethical and economic forces of the society.

The Stones of Venice

In *The Stones of Venice*, Ruskin achieves in the art of prose the ideals of a figural art that he sets forth in theory in *Modern Painters* I and II.[4] Like Carlyle, Ruskin reconciles visual and historical accuracy with transcendental revelation by writing history within the implicit model of Scripture. As much as Carlyle's, Ruskin's raw material is fact; his work is that of the romantic historian reaching back into time through the power of the sympathetic imagination in order to re-create the past for the modern reader. Like Carlyle pondering the ruins of Bury St. Edmunds, Ruskin observes the stones or buildings of Venice so as to restore the life of an earlier age. These stones, these buildings are for Ruskin, like all phenomena, a form of symbolic language that must be read not only as signs of the moral attributes of their creators but as "intrinsic" symbols of Providence operating within historical time. Furthermore, the very act of reading architecture figurally, the fusion of clear visual and historical perception with the awareness of building and past event as symbols of an encompassing moral order, exemplifies for the reader the operation of the Theoretic faculty.

Like Carlyle, Ruskin organizes his figural history by parallels to traditional, public myths. His intention of writing the history of Venice in the typological mode of the Bible, so as to show the workings of a just providence, is set forth at the beginning of the first chapter of book one, "The Quarry." He speaks of the three great thrones or kingdoms by which "dominion of men was asserted over the ocean . . . Tyre, Venice, and England" (9:17). Just as the fall of Tyre prefigures God's judgment upon Venice, so the fall of Venice is a type of the imminent fall of England: "The exaltation, the sin, and the punishment of Tyre have been recorded for us, in perhaps the most touching words ever uttered by the Prophets of Israel against the cities of the stranger. But we read them as a lovely song; and close our ears to the sternness of their warning: for the very depth of the Fall of Tyre has blinded us to its reality, and we forget, as we watch the bleaching of the rocks between the sunshine and the sea, that they were once 'as in Eden, the garden of God'" (9:17). The vision of a lost Eden, of a pre-Renaissance Venice as yet uncorrupted by pride and sensuality, informs the work. And

continuous shifts from Edenic past to fallen present provide Ruskin with one of his principal means of moralizing both Venetian history and his own visual observations. But for all the contrast of past and present, there is no reference to the future. Although the book ends with hope for the revival of Gothic architecture and for the consequent moral regeneration of Victorian England, this perfected future is not described, does not give meaning to the events of the present as it does in Carlyle's work. Carlyle as historian may walk amidst a sinful England, but it is an England that, at a midpoint in the historical continuum, provides prefigurations of a perfected future. Ruskin's figuralism diverges from Scripture in that phenomena do not stand as signs of future redemption but as symbols of the present fallen condition. Ruskin's historical perspective is always that of standing amidst corrupted mankind, in the church in Murano or in the Piazza San Marco. Carlyle sees the divine about to be incarnated anew in the industrial hero. But, Ruskin's God is the Old Testament God of Vengeance, the same God that smote Tyre, punished Venice, and will, by implication, deal similarly with England.

For Ruskin, historicism itself can become the instrument of moral regeneration. His aim, continued by the Brotherhood, is through art to re-create in the present the moralized visual sensibility that existed before the secularization of consciousness brought about by the Renaissance. To this end, Ruskin adopts the persona of a guide, in part to demonstrate that integrated or Theoretic vision is dependent upon the directing of the eye by a moral presence, in part through a lack of confidence that the materials will in themselves demonstrate their intrinsic meaning without an extensive gloss.

The structure of the "Torcello" chapter is characteristic. Ruskin, acting like a Virgil to the contemporary reader's Dante, guides the reader through the minutely pictured, fallen landscape of the present, "corrupted sea-water soaking through the roots of its acrid weeds, and gleaming hither and thither through its snaky channels" (10:17). The reader is then taken to a tower from which he perceives "an octagonal chapel, of which we can see but little more than the flat red roof with its rayed tiling, [and] a considerable church with nave and aisles, but of which, in like manner, we can see little but the long central ridge and lateral slopes of roof" (10:18). Here, the inability to see the scene in all its particularity—"we can see little"—indicates that the reader is not only outside the church, but also cut off from the religious sensibility of the past. But this journey through the demonic

world of the present acts to bring the reader into the interior of the building, to the divine world as manifested in the artifacts of the past. Ruskin as exegete explains: "The noble range of pillars which enclose the space between, terminated by the high throne for the pastor and the semicircular raised seats for the superior clergy, are expressive at once of the deep sorrow and the sacred courage of men who had no home left them upon earth" (10:21). For Ruskin, this "mute language" (10:25) of the architecture is explicitly "typical" in expressing simultaneously not only the historical circumstances of the builders but the transcendental significance of their lives: "The actual condition of the exiles who built the cathedral of Torcello is exactly typical of the spiritual condition which every Christian ought to recognize in himself, a state of homelessness on earth, except so far as he can make the Most High his habitation" (10:21–22).

Within the dramatic action, the detailed word-paintings of the interior demonstrate the careful observation that prepares the "religious spectator" (10:29) for the final moment of moralized perception. Ruskin finally asks the reader, whom he is guiding, to enter the past: "Ascend the highest tier of the stern ledges that sweep round the altar of Torcello, and then, looking as the pilot did of old along the marble ribs of the goodly temple-ship, let him re-people its veined deck with the shadows of its dead mariners, and strive to feel in himself the strength of heart that was kindled within them" (10:35). This act of historical empathy depends upon clear awareness of visual and historical fact, but its moral force lies in the transcendence of the present to re-experience, momentarily, the integrated religious sensibility of the past.[5]

The role of artist as scientist provides Ruskin with another strategy for endowing physical fact with religious significance. As nineteenth-century scientist, Ruskin must explain by returning to origins and, in "The Throne," he begins his account of the history of Venice with geology, with the evolution over geological time of the city's site. The "main fact" is the "gradual" development of the Po delta by alluvial deposits (10:10). Ruskin's analysis is minutely detailed, but ordered by the model of religious science; the more minutely the physical world is examined, the more clearly it is revealed as having been created by a benevolent God: "Had there been no tide, as in other parts of the Mediterranean, the narrow canals of the city would have become noisome. . . . Had the tide been only a foot or eighteen inches higher in its rise, the water-access to the doors of the palaces would have been impossible. . . . Eighteen inches more of difference between the level of the flood and ebb would have

rendered the doorsteps of every palace, at low water, a treacherous mass of weeds and limpets" (10:14). His assumptions are those of natural theology, and the consequent upward movement of his prose from detailed fact to providential design resembles that of Ruskin's former teacher, William Buckland, demonstrating the hand of God at work in the placement of coal deposits in England:[6] "If, two thousand years ago, we had been permitted to watch the slow settling of the slime of those turbid rivers into the polluted sea . . . how little could we have known, any more than of what now seems to us most distressful, dark, and objectless, the glorious aim which was then in the mind of Him in whose hands are all the corners of the earth!" (10:14).

By seeing architecture, too, within the context of religious science, Ruskin can moralize the work of the builder by seeing it as the analogue of the divine benevolence and intelligence manifested in the physical forms of the creation. Just as the divine energy can have the earth "heave into mighty masses of leaden rock" (10:186), so the Gothic builder "heaves into the darkened air the pile of iron buttress and rugged wall" (10:187). Just as the fitting of all organisms, of shrimps as well as tigers, to their particular environment manifests, within the context of natural theology, the intelligence and benevolence of the Creator, so the harmony of Gothic style to indigenous materials and to the surrounding landscape becomes the sign of harmony with the Creator. The Northern Gothic cathedral is, for example, praised for being "instinct with work of an imagination as wild and wayward as the northern sea" (10:187).

Because of his impulse to explicate each natural and architectural fact, Ruskin, like Carlyle, moves toward a pictorial form. Ruskin often concentrates on a specific scene, a facade or sculptured tomb, to draw the fullest symbolic meaning from each detail. Yet, because he is so occupied with the *process* of seeing, he often employs a cinematic method that traces the progress of the eye over building or landscape, zooms in to focus on minute detail, or cuts quickly to contrasting scene.[7] Through the work, and particularly in the climactic description of Saint Mark's, these methods are, however, turned toward figural purposes.

To reach Saint Mark's, Ruskin, continuing in the persona of guide, first leads the reader through the narrow valley of the Calle Lunga San Moise: "Full of people, and resonant with cries. . . . Overhead, an inextricable confusion of rugged shutters, and iron balconies and chimney flues. . . . On each side, a row of shops, as densely set as may be, occupying, in fact, intervals

between the square stone shafts, about eight feet high" (10:80). As in Brotherhood painting, the random multitudinousness of daily life not only enforces the actuality of the event but functions symbolically, here as an antitype of the artistic and moral harmony of the past. Ruskin leads the reader through the chaos of the present to the piazza where this sign of the past "rises a vision out of the earth" (10:82).

The cathedral is not described; it would be more accurate to say that the act of seeing the cathedral is described. Indeed, the eye is directed over the facade in a quite specific way—from the porches at the base, to the "Greek horses," upward to the "crests of the arches" and finally "into the blue sky" (10:83). In seeing the English cathedral, to which Saint Mark's is compared, the eye is also made to move upward, "higher and higher up to the great mouldering wall of rugged sculpture . . . higher still, to the bleak towers, so far above that the eye loses itself among the bosses of their traceries" (10:79). Here, the act of seeing, of observing contemporary objects, is moralized by correspondence with the traditional hierarchical pattern of Western religious art, upward from earthly life at the bottom of the painting or facade to God at the top. And to look at the facade with the eye moving ever upward toward God is to recapture, for the moment, the fusion of religious faith and structural skill in the original builders.

In this section, too, buildings are transformed into natural objects identified with the surrounding landscape. The facade of the English cathedral becomes the rugged northern landscape seen from above in "The Nature of Gothic" (10:186–87). Covered with "deep russet-orange lichen," the northern facade is host to a "crowd of restless birds" whose cries are like "the cries of birds on a solitary coast between the cliffs and sea" (10:79). The facade of Saint Mark's holds eternally in static form the vital energy of the Mediterranean seascape: "The crests of the arches break into a marble foam, and toss themselves far into the blue sky in flashes and wreaths of sculptured spray, as if the breakers on the Lido shore had been frost-bound before they fell" (10:83). Although Ruskin remarks, "Between that grim cathedral of England and this [Saint Mark's], what an interval!" (10:84), the identity of each building with its natural setting figures its harmony with the divine order, and thus the builders' clear perception of and reverence for the divinely created world.

The vitalized architecture of the facade becomes a garden of "palm leaves and lilies, and grapes and pomegranates" (10:82), but this is an Eden closed to the modern, fallen viewer. "The

solemn forms of angels . . . [are] indistinct among the gleaming of the golden ground through the leaves beside them, interrupted and dim, like the morning light as it faded back among the branches of Eden, when first its gates were angel-guarded long ago" (10:82–83). As in "Torcello," the possibilities and the limitations of moralized vision for the nineteenth century are measured by the ability to perceive with minute accuracy. The viewer does not enter this Eden, but sees it as Adam and Eve did at the moment of their expulsion, "when first its gates were angel-guarded long ago." The carved forms of the facade, of the sculptured garden of the lost Edenic world, are "indistinct . . . interrupted and dim," and the sudden blurring of sight in what has up to this point in the passage been acute visual perception of architectural detail dramatizes in itself the interdependence of visual clarity and moral strength. The moment of transcendence through historical empathy is limited; from the indistinct and momentary vision of a past Eden, the reader returns to the fallen mankind in the Piazza San Marco.

It is in placing the richly detailed representation of Saint Mark's within the historical process that Ruskin's pictorial methods are closest to those of the Brotherhood. The porches of Saint Mark's are "full of doves, that nestle among the marble foliage, and mingle the soft iridescence of their living plumes, changing at every motion, with the tints, hardly less lovely, that have stood unchanged for seven hundred years" (10:84). Through evident iconographic reference, the minutely observed natural detail points toward the transcendent. The pigeons nesting in the cathedral facade, much like the dove in *The Carpenter's Shop* (plate 5), become a type of the Holy Spirit. Saint Mark's becomes, then, a type of the ancient Temple: "The foundations of its pillars are themselves the seats—not of 'them that sell doves' for sacrifice, but of the vendors of toys and caricatures" (10:84). The entire scene, then, reenacts in the historical present the pattern of fall and corruption prefigured in Scripture.

1. Albert LaValley, in *Carlyle and the Idea of the Modern* (New Haven: Yale University Press, 1968), chap. 4, notes the "Puritan" quality of the work, but does not develop the idea of figural or typological structure.

2. See Robert Southey, *Sir Thomas More; or, Colloquies on the Progress and Prospects of Society* (1829); Thomas Babington Macaulay, "Southey's Colloquies" (1830); A. W. Pugin, *Contrasts; or, A Parallel Between the Noble Edifices of the Fourteenth and Fifteenth Centuries, and Similar Buildings of the Present Day; shewing the Present Decay of Taste* (1836; second and much revised ed. 1841).

3. Title of bk. 3, chap. 1. Page numbers will be given in parentheses in the text and for convenience refer to *Past and Present*, ed. Richard D. Altick (Boston: Houghton Mifflin, 1965).

4. There is relatively little discussion of the art of Ruskin's prose in *The Stones of Venice*. See John Rosenberg, "Style and Sensibility in Ruskin's Prose," in *The Art of Victorian Prose*, ed. George Levine and William Madden (New York: Oxford University Press, 1968), pp. 177–200; Wendell V. Harris, "The Gothic Structure of Ruskin's Praise of Gothic," *University of Toronto Quarterly* 40 (1971): 109–18; Stein, *Ritual of Interpretation*, chap. 3.

5. In *The Ritual of Interpretation*, Stein sees this ceremony of entering the past through art as central to Ruskin's work, chap. 3.

6. *The Bridgewater Treatises on the Power Wisdom and Goodness of God as Manifested in the Creation; Treatise VI, Geology and Minerology Considered with Reference to Natural Theology* (London: Pickering, 1837), 1:553–54.

7. In "Style and Sensibility in Ruskin's Prose," Rosenberg notes cinematic elements, pp. 185–86.

Chapter Three

The Brotherhood Aesthetic

Looking back at the end of the century, Hunt marked the origin of the Brotherhood in a conversation of 1846 with Millais in which he shared his own intense excitement on reading the second volume of *Modern Painters:* "Lately I had great delight in skimming over a certain book, *Modern Painters,* by a writer calling himself an Oxford Graduate; it was lent to me only for a few hours, but, by Jove! passages in it made my heart thrill" (Hunt, 1:90). Hunt's sensibility focused on Ruskin's discussion of "Imagination Penetrative," and particularly on Ruskin's typological reading of Tintoretto's *Annunciation:* "The Annunciation takes place in a ruined house, with walls tumbled down; the place in that condition stands as a symbol of the Jewish Church—so the author reads—and it suggests an appropriateness in Joseph's occupation of a carpenter, that at first one did not recognise; he is the new builder!" (Hunt, 1:90). During his Brotherhood phase, Rossetti shared this enthusiasm for Ruskin's historicist theory of scriptural painting. As late as 1856, he writes to Browning praising the anti-Raphaelite arguments in the latest volume of *Modern Painters:* "I'm about half-way through Ruskin's third volume which you describe very truly. Glorious it is in many parts—how fine that passage in the 'Religious false ideal,' where he describes Raphael's *Charge to Peter,* and the probable truth of the event in its outward aspect. A glorious picture might be done from Ruskin's description" (*Letters,* 1:286). [1]

For Hunt, Rossetti, and Millais, then, the primary issues in the formation of the Brotherhood were not only the achievement of a more accurate representationalism in opposition to Academic conventions but the revitalization of religious art through methods appropriate to their own age. Hunt recalls confessing to Millais in this 1846 conversation: "You feel that the men [the Venetian painters] who did them had been appointed by God, like old prophets, to bear a sacred message, and that they delivered themselves like Elijah of old" (Hunt, 1:90). In their theory, if not always in their practice, the Brothers too sought to "bear a sacred message." From the essays in their single public manifesto, *The Germ,* and scattered statements of the circle during the Brotherhood period there emerges a coherent, self-

conscious position that calls for the continuation of the pure tradition of sacramental Christian art through the distinctly contemporary mode of figuralism articulated by Carlyle and Ruskin. Within this context, the paradoxes that puzzle the modern mind—the joining of minute realism with sacramental intention, of archaeological accuracy with faith in Scripture as revelation, of revivalist purpose with nineteenth-century style—are reconciled through the intellectual models used by Carlyle and Ruskin: the analogy of the artist to the religious scientist and a figural approach to history. And yet, ironically, this effort to restore at the midpoint of the nineteenth century what they saw as the single authentic tradition of sacred art brought the Brothers, for a time, into a stance of opposition toward their audience and a distinctly modern relationship to artistic tradition.

To the formation of their aesthetic, the Brothers brought sensibilities shaped by varying modes of figuralism. Hunt, the most authentically religious of the group, came from a firmly Protestant, deeply puritanical background. Like Carlyle and Ruskin, Hunt grew up in a family in which Bible-reading was a major family occupation. In the most recent biography, his granddaughter says, "At the age of five, his favorite day of the week was Sunday. . . . Like all their neighbours, the Hunts put on their best clothes and went to church. After the evening meal and family prayers, his father read aloud from the New Testament."[2] Hunt himself remained self-consciously proud of his Calvinist heritage, noting in his autobiography that "our earliest recorded ancestor had taken part against King Charles and at the Restoration had sought service in the Protestant cause on the Continent" (Hunt, 1:3). Having rebelled against his father in following an artistic rather than commercial career, Hunt justified his work as a form of ministry engaged in painting visual sermons based upon Scripture, contemporary life, or imaginative literature. Always, he thought of himself as working in the tradition of English Protestant art. He notes with pride and a hint of prefiguration, "I was christened at the church of St. Giles, Cripplegate, in which Cromwell was married, and where the toil-worn body of Milton lies" (Hunt, 1:4).

Dante Gabriel Rossetti was neither English nor Protestant, yet the mental habits he brought from his own background drew him, for a time, toward figural methods. As a young man, Rossetti attended with his family churches known for their Tractarian leanings; and in the late 1840s and into the early 1850s, he seems to have been caught up in the resurgence of religious feeling brought about by the Oxford Movement.[3] But for Ros-

setti, the figural tradition was mediated primarily through
Dante, particularly through the *Vita Nuova*. Auerbach's com-
ments on the *Vita* in his essay "Figura" exactly describe the
young Rosetti's sense of this work:

> For Dante the literal meaning or historical reality of a figure stands
> in no contradiction to its profounder meanings, but precisely
> figures it; the historical reality is not annulled, but confirmed and
> fulfilled by the deeper meaning. The Beatrice of the *Vita Nuova* is
> an earthly person; she really appeared to Dante, she really saluted
> him, really withheld her salutation later on. It should also be
> borne in mind that from the first day of her appearance the earthly
> Beatrice was for Dante a miracle sent from Heaven, an incarnation
> of Divine truth.[4]

It is this same sense of the interpenetration of sacred and histor-
ical reality that not only informs Rossetti's Brotherhood illus-
trations of the *Vita* but also shapes his biblical paintings and
treatments of contemporary events. And yet, the close connec-
tion of figural methods with erotic feelings in Dante's *Vita* was
also absorbed by Rossetti, leading him, even within his Brother-
hood work, toward the use of Dantean material as a vehicle for
private emotions.

Millais brought to the Brotherhood little feeling for the sacred.
His father was a person of inherited wealth and no occupation;
the description of him as "a man of no ambition save where his
children were concerned, and who desired nothing more than
the life he led as a quiet country gentleman"[5] prefigures ele-
ments in his son's career. With no firm religious or intellectual
background to draw upon, Millais did not shape the Brother-
hood aesthetic, but rather joined the group out of youthful
enthusiasm and carried out its aims with his almost preter-
natural technical skill. But painting was always to Millais less a
calling than the career track leading to the prosperous life of a
country gentleman, and he left the Brotherhood as easily as he
originally joined.

For all their varied backgrounds, during the Brotherhood
years the members of the group thought of themselves as, and
acted as, artist-scientists.[6] In the major theoretical essay in *The
Germ*, "The Purpose and Tendency of Early Italian Art," F. G.
Stephens, one of the original Brothers, quite explicitly identifies
the mission of the Brotherhood with that of contemporary sci-
ence: "The sciences have become almost exact within the pres-
ent century. Geology and chemistry are almost re-instituted.
The first has been nearly created; the second expanded so widely
that it now searches and measures the creation. And how has

this been done but by bringing greater knowledge to bear upon a wider range of experiment; by being precise in the search after truth? If this adherence to fact, to experiment and not theory . . . has added so much to the knowledge of man in science; why may it not greatly assist the moral purposes of the Arts?" (*Germ*, 61). In working to reproduce the particular object set before him, whether a beech post in the studio, a hedge in Knole Park, or the musculature of a carpenter's arms, the Brotherhood artist is emulating the scientist's "adherence to fact," to the visible truth of the particular specimen before him. In moving from the studio to work *en plein air*, in the obsessive search for the perfect wall or riverbank, he is following the scientist's "adherence . . . to experiment," to the observation of natural phenomena *in situ*. And in reporting on canvas the results of his direct observation, the Brotherhood artist is demonstrating a scientist's "adherence . . . to experiment and not theory"; he is testing the authority of Academic conventions against observed fact much as the scientist tests received theory against experimental observation.

It even appears that the Brotherhood in their practice consciously drew upon the scientific theory of their time. In his *Memoir* of Hunt, Stephens describes Hunt's purposes in representing light and shadow in *The Hireling Shepherd* (R.A., 1852) (plate 18) as the "scientific elucidation of that particular effect which, having been hinted at by Leonardo da Vinci . . . was partly explained by Newton, and fully developed by Davy and Brewster. He was absolutely the first figure-painter who gave the true colour to sun-shadows, made them partake of the tone of the object on which they were cast, and deepened such shadows to pure blue where he found them to be so" (Stephens, *Hunt*, 20). Although Stephens's comment does provide a "rather muddled assessment"[7] of the origins of Hunt's style, the remark does indicate how much the Brothers saw their own technical innovations, in this case the use of colored shadows, as participating in the scientific progress of their own age.

This effort to see the world directly by shedding the visual preconceptions of the past also led the Brothers to emulate the style of the scientist as artist, in particular that of the scientist, like Philip Gosse, who illustrated his own texts (plate 1). As the testimony of Edmund Gosse suggests, the Brotherhood style closely approaches that of scientific illustration. The hard-edge manner and full modeling emphasizes the separateness of the physical object, its importance as a specimen. The minute particularity and the pushing of the object to the front of the picture plane as well as the rejection of chiaroscuro for a bright overall

illumination indicates the necessity of observing and recording each detail of each specimen. Again, we may note the shock of recognition of Philip Gosse and his son in finding "the exact, minute and hard execution of Mr. Hunt to be in sympathy with the method we ourselves were in the habit of using when we painted butterflies and seaweeds."[8]

This identification with the scientist also provided a moral justification for their minute realism. The Brothers shared Stephens's assumption that if "adherence to fact, to experiment and not theory . . . has added so much to the knowledge of man in science," the same scientific modes would inevitably "greatly assist the *moral* purposes of the Arts" (*Germ*, 61, italics added). Using a Ruskinian vocabulary that fuses mimetic and moral criteria, Stephens speaks of the new school of English artists as "producing pure transcripts and faithful studies from nature" (*Germ*, 58). He urges artists to "believe that there is that in the fact of truth, though it be only in the character of a single leaf earnestly studied, which may do its share in the great labor of the world" (*Germ*, 64). His language assumes an inherent significance that will emerge from the accurate transcript of the natural world and of human events as surely as from the fact itself. He praises "the power of representing an object, that its entire intention may be visible, its lesson felt" (*Germ*, 60). And he exhorts the reader, "Never forget that there is in the wide river of nature something which everybody who has a rod and line may catch, precious things which every one may dive for" (*Germ*, 60).

In his two *Germ* essays on "The Subject in Art," John Tupper also assumes the moral value of the scientific method in arguing for the Brotherhood belief in an art of high moral dignity derived from close observation of modern life. For Tupper, the science that the artist must follow is that of natural theology: "Science here does not make; it unmakes, wonderingly to find the making of what God has made. . . . But though science is not to make the artist, there is no reason in nature that the artist reject it" (*Germ*, 13). The artist, then, like the religious scientist, must find God through accurate representation of the world about him, rather than in rehearsing artistic traditions passed down by the Academy: "Thus then we see, that the antique, however successfully it may have wrought, is not our model; for, according to that faith demanded at setting out, fine art delights us from its being the semblance of what in nature delights" (*Germ*, 14). Faithfully imitated on canvas, the visible world will create the same response as the divinely created natural fact itself: "Works

of Fine Art affect the beholder in the same ratio as the *natural prototypes* of those works would affect him" (*Germ*, 118).

In their scattered statements about their own work, the major Brotherhood artists also connect the close observation of natural fact with religious purpose. In his sonnet "St. Luke the Painter," written in 1849, Rossetti writes of early-Renaissance art as knowing

> How sky-breadth and field-silence and this day
> Are symbols also in some deeper way,
> She looked through these to God and was God's priest.

Characteristically, Hunt uses a Ruskinian vocabulary: "Our object was to be enslaved by none, but in the field of Nature and under the sky of Heaven frankly to picture her healthful beauty and strength" (Hunt, 2:452). Both "field" and "sky" are modified by a capitalized possessive to show the visible fact as the creation of, and sign of, a transcendent power. And "beauty" is modified by "healthful" to emphasize the Ruskinian principle that the accurate representation of the visible landscape is not merely an aesthetic occupation but a means of restoring moral vigor.

The belief that each detail of nature figures the transcendent appears to be the message of *Convent Thoughts* (R.A., 1851), by Charles Collins, a young artist who, while executing this work, was part of the Brotherhood circle. Here, the nun lays aside the Book of God, an illustrated missal, to read from the Book of Nature, to examine closely a daisy plucked from the convent garden. In her chaste holiness, figured by the lily, able to find God not only through His revealed word but also through Wordsworthian observation of a common flower, the nun represents the integrated sensibility toward which the Pre-Raphaelite artist aspired. The very style of the painting, its detailed realism, becomes significant, then, in illustrating the mode of perception symbolized by the nun. To Ruskin, this naturalistic accuracy was the chief virtue of the work. In one of the letters to the *Times* of 1851, he praises the painting as a scientific illustration: "As a mere botanical study of the water lily and *Alisma*, as well as of the common lily and several other garden flowers, this picture would be invaluable to me" (12:321). But, using the religiously resonant vocabulary of *Modern Painters*, he also notes that the scientific style in which the specimens are "so well drawn" shows that these artists do not "sacrifice *truth* as well as feeling to eccentricity" (12:321).

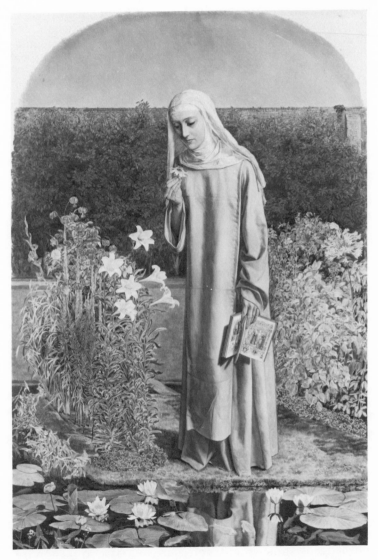

PLATE 3. Charles Collins, *Convent Thoughts*. Courtesy of the Ashmolean
Museum, Oxford.

This equation of detailed realism and sacred purpose is also implicit in the group's choice of a name. Drawing upon new models of art history popularized in the 1840s by such writers as Mrs. Jameson, Lord Lindsay,[9] and, of course, Ruskin, the Brotherhood sees the pre-Raphaelite artists, those representational painters that have moved beyond medieval style and yet precede Raphael—"Gozzoli . . . Ghiberti . . . Fra Angilico . . . Masaccio . . . Ghirlandajo . . . Orcagna . . . Giotto" (*Germ*, 61–62)—as the last to have confronted the visible world directly, to have perceived it clearly, to have represented it exactly. For, just as the true scientist confronts the natural world openly, freed from the distorting effect of false theories passed down on the authority of tradition, so, according to the Brotherhood, the early Italian artist perceived nature with a similar directness by not having imposed between the eye and the visible fact the distorting artistic conventions created by Raphael, imposed by his followers, and fossilized into the theory and educational practice of the Royal Academy. Stephens, in "The Purpose and Tendency of Early Italian Art," lauds these early-Renaissance artists for their "success, by following natural principles, until the introduction of false and meretricious ornament led the Arts from the simple chastity of nature, which it is as useless to attempt to elevate as to endeavour to match the works of God by those of man" (*Germ*, 62).

To the Brotherhood, as to Ruskin, the clarity of mimesis in the artists immediately preceding Raphael is a sign of religious strength. The work of these artists represents to the Brotherhood what the facade of Saint Mark's does to Ruskin, the manifestation of the integrated faculty in which visual acuteness and religious awareness are fused. Within this model of art history, then, the work of Raphael, praised by the Academy as the highest achievement of Western art becomes, instead, the point of decline. For the Brotherhood, as for Ruskin in *Modern Painters* II and *The Stones of Venice,* the failure of mimetic accuracy in the Grand Style, particularly its non-historicist idealization, demonstrates the secularization of the artistic consciousness. Stephens praises Masaccio as differing from a High Renaissance artist in manifesting the visual awareness that comes from a sense of the natural world as the creation of God: "For as the knowledge is stronger and more pure in Masaccio than in the Caracci, and the faith higher and greater,—so the first represents nature with more true feeling and love, and with a deeper insight into her tenderness; he follows her more humbly, and has produced to us more of her simplicity; we feel his appeal to

be more earnest" (*Germ*, 60). For Stephens, "the introduction of false and meretricious ornament" by Raphael "led the Arts from the simple chastity of nature" (*Germ*, 62). In John Orchard's "Dialogue" in *The Germ*, Christian says, "Nature itself is comparatively pure; all that we desire is the removal of the fictitious matter that the vice of fashion, evil hearts, and infamous desires graft upon it" (*Germ*, 151).

It is this historical scheme that Rossetti allegorizes in "St. Luke the Painter." In this poem, the early Italian painters alone are able to be simultaneously representational and devotional by painting "sky-breadth and field-silence" as "symbols." The early Renaissance, then, becomes the apogee of Western art. In the High Renaissance, "past noon," when the artist rejects the service of a religious art, when "her toil began to irk," he inevitably turns from the direct observation of the natural world to the mere reiteration of humanly created artistic formulas. In Rossetti's terms, the Raphaelite artist "sought talismans, and turned in vain / To soulless self-reflections of man's skill."

If the Brotherhood saw sacred meaning as emerging from the accurate representation of natural fact, the artists looked for the same divine significance to emerge from the equally scientific recording of historical fact. In their extensive treatment of both biblical and postbiblical history, the Brothers sought not to revive the style of the painters preceding Raphael but to achieve a sacred art through the historical methods they saw as characterizing the spirit of their own age.[10] In his essay "On the Mechanism of a Historical Picture" in *The Germ*, Ford Madox Brown outlines the methods of achieving archeological accuracy carried out by the group: "The first care of the painter, after having selected his subject, should be to make himself thoroughly acquainted with the character of the times, and habits of the people, which he is about to represent; and next, to consult the proper authorities for his costume, and such objects as may fill his canvas; as the architecture, furniture, vegetation or landscape, or accessories, necessary to the elucidation of the subject" (*Germ*, 70). The puzzling association of this distinctly nineteenth-century historicism with the early-Italian painters derives from the Ruskinian model of art history. To the Brothers, the chief failure of the Raphaelite manner is that the idealizing style, exemplified in Raphael's cartoons for the Vatican tapestries, appears to repudiate the historicity of scriptural events. To the Brotherhood, it seemed that only the artists immediately preceding Raphael, those painting in a realistic manner, but as yet uncorrupted by the heroicizing conventions of the Grand

Style, could still feel the quotidian reality of biblical events while still realizing their sacred meaning. In his essay on early-Italian art, Stephens illustrates how these "earlier painters came nearer to fact," how they "were less of the art, artificial" (*Germ*, 60), through the example of a Florentine Pietà. His main point is that the work achieves its religious power through historical accuracy. In this Pietà, the Virgin "is old, (a most touching point); lamenting aloud, clutches passionately the heavy-weighted body on her knee; her mouth is open." Stephens notes that this realism, "this identification with humanity," is far superior to any Raphaelite idealization, to any "refined or emasculate treatment of the same subject by later artists, in which we have the fact forgotten for the sake of the type of religion, which the Virgin was always taken to represent, whence she is shown as still young" (*Germ*, 60).

Although it is difficult to share the Brotherhood's excitement over Carlo Lasinio's engravings from the Campo Santo, the group appreciated these fourteenth- and fifteenth-century works as representing the power of a historical, as opposed to Raphaelite, treatment of scriptural subjects. The subjects themselves are clearly typological. *The Departure of Hagar from the House of Abraham* is mentioned by Saint Paul as prefiguring the replacement of the Old Covenant by the New (Gal. 4:22–31); *The Sacrifice of Isaac* is a type of the Sacrifice of Christ. Although these works do not show the nineteenth-century archeological accuracy that the Brotherhood sought, they do give the sense of random daily reality by showing the central action as occurring within domestic, rather than generalized, heroic settings. In *The Sacrifice of Isaac*, as Abraham prepares for his journey, two young boys playfully fight and the servant readies the mule. After the intervention by the angel, Abraham and Isaac eat together attended by their servants, while the mule grazes peacefully nearby. Nor were the Brothers the only Victorians to be impressed by the figural quality of these works. In a letter to his father from Pisa in 1845, Ruskin writes with enormous enthusiasm of the power of these frescoes, particularly of *The Departure of Hagar*, in impressing upon the viewer the historical reality of scriptural events:

> The Campo Santo is the thing. I never believed the patriarchal history before, but I do now, for I have seen it. . . . In spite of every violation of the common, confounded, rules of art, of anachronisms & fancies . . . it is Abraham himself still. Abraham & Adam, & Cain, Rachel & Rebeka, all are there, the very people, real, visible, created, substantial, such as they *were*, as they must have been—one cannot look at them without being certain

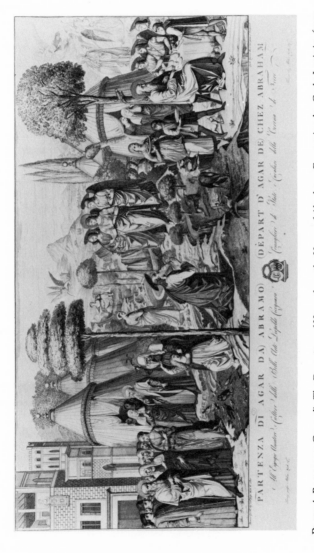

PLATE 4. Benozzo Gozzoli, *The Departure of Hagar from the House of Abraham*. Engraving by Carlo Lasinio, from *Pitture a fresco del Campo Santi di Pisa, intagliate* (Florence, 1841). Reproduced by courtesy of the Trustees of the British Museum.

that they have lived. . . . Abraham sits *close* to you entertaining the angels—you may touch him & them—and there is a woman behind bringing the angels some real, *positive* pears.[11]

Hoping, like Carlyle and Ruskin, to find spiritual as well as artistic regeneration through historicism, the Brotherhood sought to re-create in the present the moralized imagination represented by the early-Italian artists. The very drive to create a close, fraternal group with the religiously resonant name of "Brotherhood," the paraphernalia of rules, the regular meetings, and the secrecy transcend their evident juvenility as attempts to re-create a communal consciousness in their own lives that would inevitably be expressed in their art. Although the Brothers knew, primarily through Ford Madox Brown, of the methods and the living habits of the Nazarenes, they were too Protestant, too imbued with the Victorian idea of historical development, perhaps simply too young and sexually vigorous, to don the monk's robe of the pre-Renaissance artist. In his essay on early-Italian art, Stephens takes direct issue with the Nazarene attempt to duplicate the life of the medieval artist: "The modern artist does not retire to monasteries, or practise a discipline; but he may show his participation in the same high feeling by a firm attachment to truth in every point of representation" (*Germ*, 59).

Stephens thus articulates the paradox at the center of the Brotherhood enterprise—that the artist can express the "high feeling" or religious imagination of the past through the use of artistic modes characteristic of the present, in particular through a "firm" scientific and historicist "attachment to truth . . . of representation." The aim of the Brotherhood, then, was not to mimic the style of fifteenth-century art but to employ the perceptual and artistic modes of the present to restore the integrated sensibility that, looking through Ruskin's eyes, they saw exemplified in the past.

Ironically, the Brotherhood effort to restore a public religious art set them, for a time, in a role defined by opposition. The choice of a name, the formation of a society as an alternative to the Royal Academy, the issuing of *The Germ* as a manifesto, the un-Academic use of brilliant color, hard-edge outline, and random composition clearly indicate the Brothers' rejection of the one institution through which one could, in mid-Victorian England, hope to become a successful artist. And yet, in opposing the Academy, the Brothers did not see themselves in the avant-garde model of breaking entirely with artistic tradition in order to create an art that is entirely new.[12] Instead, they speak only of

rejecting the false tradition codified by the Academy in order to restore the authentic tradition cut off by the High Renaissance. This justification of innovation as the continuation of the true tradition found far back in history links the Brotherhood with movements of the later-nineteenth and early-twentieth century. William Morris, while creating highly Victorian designs, saw himself as restoring the pure tradition of English folk art destroyed by the introduction of foreign styles and the division of labor in the High Renaissance. Early in his career, Yeats looked beyond late-nineteenth-century aestheticism to the disappearing traditions of Celtic Ireland. And T. S. Eliot, the most influential modern writer on the uses of tradition, postulates the theory of a dissociation of sensibility in the seventeenth century remarkably similar to the idea of a dissociation of visual and moral awareness in the Renaissance that informs the historical model of Ruskin and the Brotherhood. For the Brotherhood, as for these later writers, the appeal to the single authentic tradition expresses their sense of a complex relation to history. It is true, but only partly true, that the Brotherhood invocation of the early-Italian painters is a means of finding what Renato Poggioli calls "patents of nobility" for innovations in the present.[13] It is equally true that their name indicates their own perception that for all their originality of style and participation in the scientific and historicist impulses of their own age, there is a genuine continuity between their work and an earlier sacramental art.

1. Rossetti refers to chap. 4, "Of the False Ideal:—First, Religious," *Modern Painters* III.

2. Diana Holman-Hunt, *My Grandfather, His Wives and Loves*, (London: Hamilton, 1969), p. 32.

3. See the interesting discussion of Rossetti's Tractarian background in D. M. R. Bentley, "The Belle Assemblée Version of 'My Sister's Sleep,'" *Victorian Poetry* 12 (1974): 321–34, and "Rossetti's 'Ave' and Related Pictures," *Victorian Poetry* 15 (1977): 21–35.

4. Auerbach, pp. 73–74.

5. John Guile Millais, *The Life and Letters of Sir John Everett Millais* (New York: Frederick A. Stokes, 1899), 1:1.

6. The discussion of the Brotherhood as antiscientific in such works as John Dixon Hunt, *The Pre-Raphaelite Imagination, 1848–1900* (London: Routledge, 1968) fails to consider the religious basis of the scientific ideas upon which the Brotherhood drew.

7. Staley, *The Pre-Raphaelite Landscape*, p. 24. See Staley, pp. 23–26, for discussion of the technical innovations in Hunt's treatment of landscape.

8. Gosse, *Father and Son*, p. 184.

9. Anna Jameson's series *Sacred and Legendary Art* first appeared in 1848. Lord Lindsay's *Sketches of the History of Christian Art* was published in 1847, *Modern Painters* II in 1846.

10. For a discussion of Brotherhood concern with historical accuracy, see Jerome H. Buckley, *The Triumph of Time* (Cambridge, Mass.: Harvard University Press, 1966), pp. 14–17, and "Pre-Raphaelite Past and Present: The Poetry of the Rossettis," in *Victorian Poetry*, Stratford-Upon-Avon Studies, No. 15 (London: Edward Arnold, 1972), pp. 123–39.

11. Harold I. Shapiro, ed., *Ruskin in Italy; Letters to His Parents* (Oxford: Clarendon Press, 1972), pp. 67–68.

12. Renato Poggioli, *The Theory of the Avant-Garde* (Cambridge, Mass.: Harvard University Press, 1968), p. 30.

13. Ibid., p. 70.

Chapter Four

SCRIPTURE AS HISTORY

 About suffering they were never wrong,
The Old Masters: how well they understood
Its human position.
 "Musée des Beaux Arts," W. H. Auden*

The Brotherhood's figuralism is executed most directly and most consistently in the treatment of scriptural subjects. Self-consciously termed "Christian Art design" (*PRBJ,* 9) or "sacred picture" (*PRBJ,* 13), biblical painting was a major occupation of the circle and forms an important portion of its production during the Brotherhood years. In one sense, these works can be considered literary paintings, attempts to translate Scripture into an equally typological visual language. More importantly, they can be seen as a form of history painting in representing as accurately as possible the appearance of an event that actually occurred, or that might have occurred. It is through this historical treatment of Scripture that the Brotherhood can most nearly show historical fact as figure since, particularly to their Protestant audience, the associations of biblical events are so immediately present that to show the biblical action is simultaneously to present its transcendental significance.

The work that most clearly exemplifies Brotherhood aims for biblical painting, and thus most clearly exhibits the implicit tensions of this position, is Millais's *Christ in the House of His Parents* (R.A., 1850), also known as *The Carpenter's Shop.* There is, most strikingly, a virtually obsessive concern for the particularity of physical fact. Millais worked in his studio from two sheepsheads obtained from a nearby butcher; he used his father as a model for Joseph's face, but a London carpenter for the exact musculature of the arms. And if, in his hard-edged style and clear modeling of each specimen-object, he is emulating the scientist, in his imaginative re-creation of the domestic reality of the childhood of Jesus, he is emulating the contemporary historian. As in the writings of Carlyle and Ruskin, the very form works to draw the audience into participation in the events

*W. H. Auden, *Collected Poems,* ed. Edward Mendelson. Copyright 1940 and renewed 1968 by W. H. Auden; reprinted by permission of Random House, Inc., and Faber and Faber Ltd.

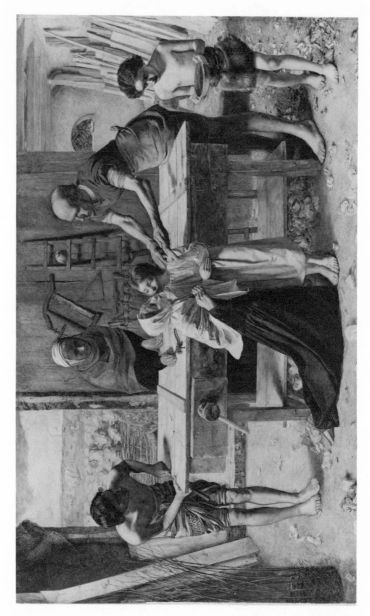

PLATE 5. John E. Millais, *Christ in the House of His Parents*. The Tate Gallery, London.

of the past. In this characteristic Brotherhood composition, the use of a three-sided room, presumably historically accurate in showing the open-fronted shops of the East, sets the viewer into the role of passer-by, an unobserved witness to an actual event. Even the use of members of the Brotherhood circle as models enforces the sense of participation in significant events of the past; historical empathy becomes a means of transcending the secular present.[1]

As religious artist, Millais sought not only to enforce the historical reality of Jesus but also to suggest through this imagined event the prefigurative quality of each action in His life. As William Michael Rossetti notes of the painting, "[It is a] typical utterance. . . . Of the treatment . . . we need only say that it is throughout human—the types humanly possible and probable (never merely symbol independent of the action)" (*Fine Art*, 204–5). As in the prose of Carlyle and Ruskin, this transformation of thoroughly "human" actions into figure is achieved through formal correspondence with traditional symbols. The sheep could perfectly well be kept by a Galilean carpenter, and yet, through a readily available public reference, they figure Christ's future mission as Shepherd and His Sacrifice. Similarly, the dove upon the ladder is painted as a natural fact, without a nimbus, but becomes through an equally available visual parallel, a figure for the appearance of the Paraclete at the Crucifixion. But, since Millais can create religious resonance only through reference to public symbols, he must work into his historical scheme just those iconographic conventions that the Brotherhood dismissed as drained of meaning by centuries of use. The young John the Baptist wears a fur loincloth. The wounded palm and the blood dripping on Jesus' foot form the stigmata; the kneeling Mary presents a visual allusion to a Pietá.

The overall form also emphasizes its visual equivalence to the typological quality of Scripture. The painting was originally exhibited with no title, only with the words from Zechariah 13:6: "And one shall say unto him, What are these wounds in thine hands? Then he shall answer, Those with which I was wounded in the house of my friends." To the audience steeped in biblical exegesis, this verse is a clear reminder that just as the events of the Old Testament prefigure those of the New, so this event of Jesus' childhood prefigures subsequent events in His life. As a whole, then, the work resembles an Interpreter's Bible in which the New Testament text is glossed through references to prefigurative events in the Old. And yet the characteristic Brotherhood habit of providing a verbal gloss to their paint-

ings suggests, as much as do the overt visual allusions on the canvas, the unacknowledged necessity of giving meaning to their invented subjects through clearly available parallels to traditional iconography.

In accord with Brotherhood ideas, Millais is trying to re-create the figural mode of Scripture not by imitating the early-Italian painters but by employing the methods that characterize the nineteenth century, in particular through what William Michael Rossetti in his important essay "The Externals of Sacred Art" (1857) calls "naturalism . . . the consentaneous tendency of all the living art of the time . . . more systematic, more downright, and more thorough . . . than has ever before been sought or professed by art" (*Fine Art*, 42). And here, as in other Brotherhood work, the style of the scientist becomes an appropriate means of expressing figural vision. Each natural fact is treated as a specimen, given a clear focus of definition irrespective of the distance from the notional picture plane; the face of Mary and the shavings are modeled with the same hard-edge distinctness as the dove and ladder in the background. Rejecting the theatrical chiaroscuro advocated by the Academy, Millais fills the canvas with bright, uniform light so that shavings and stigmata receive as much illumination as the boards at the periphery. This lack of visual distinction opposes the Academic composition in which the lines of the painting point toward the central event, the prefiguration of the stigmata. This equality of visual emphasis, then, expresses the perception, shared by Carlyle and Ruskin, that no matter how apparently trivial, each fact in the phenomenal world is meaningful if only read rightly; shavings as well as stigmata, dove as well as carpentry tools (as Ruskin demonstrated in his reading of Tintoretto's *Annunciation*) lead toward the same sacramental truth. Only when sacramental assumptions weaken or disappear, do the minute particularity and overwhelming detail appear to the viewer as showing an accidental universe in which boards and baskets, nails and human bodies, doves and sheep are merely tangible, contiguous objects. [2]

Although in theory, each object, every historical event embodies transcendental meaning, the problem for the artist lies in communicating this virtually infinite symbolic richness. In a letter on *The Hireling Shepherd*, Hunt notes, "In my mind incidents for treatment by Art are either extraneous facts or typical circumstances. A man walking along a road is an example of what I mean by the first. But one setting out from his home or arriving at his journey's end becomes a subject of a typical

kind."[3] Although sacramental theory would not admit to "extraneous facts," Hunt seems to mean by this term incidents that do not in themselves elicit strong symbolic resonance. Hunt sees that in order to convey symbolic meaning through a realistic style, the artist cannot merely reproduce the visible world, but must carefully select subjects "of a typical kind," those that, like the example of "one setting out from his home," carry traditional associations. But within a style that rejects Raphaelite abstraction, the canvas cannot consist wholly of "typical circumstances"; there remain "facts" that are, within Hunt's terms, indeed "extraneous" in being outside any public iconographic system.

In the specific case of *The Carpenter's Shop*, only the natural facts that correspond to traditional iconography, such as the sheep, the dove, the wounds, become easily available to a public reading. As appalled as the contemporary critics were by the stylistic divergence of the work, they found the typological meaning of the central event easily accessible. The reviewer for the *Art Journal*, for example, writes, "The child Jesus has wounded his hand and in showing it to his mother she kisses him. This is a prefiguration of the Crucifixion; and John brings a vessel of water in order that the wound may be washed. This is an allusion to the future mission of St. John."[4] Difficulty arises in reading the other natural facts that are given an equal stylistic emphasis—the basket at the lower left, the door itself, the shavings—but exhibit no evident iconographic associations. Within the figural context, the impulse is to search for meaning in each detail, but in a work committed to representing the multitudinousness of the visible world, a complete symbolic reading appears impossible. Some details of the painting remain, in Hunt's term, "extraneous facts."

The difficulty in reading *The Carpenter's Shop*, the tension between public and private symbol, between allusion to traditional iconography and a wholly novel subject, point to the inherent difficulties that emerged in carrying out Brotherhood aims. The Brothers' purpose was to revitalize the tradition of sacred art and thus restore to the artist the lost role of public sage. In spite of their creation of a small, tightly bound group and the public secret of their name, they sought to create an art whose appeal was not inward to the initiated but outward to the general public. Their choice of name expresses the desire to recall the artist to the position that he occupied in the period preceding Raphael when, as integrated member of the society, he could represent in vivid yet intelligible form the shared moral

and religious values of the community. The Brotherhood strategy was to restore this function by effecting a Wordsworthian revolution in the language of art. Just as Wordsworth had restored the vatic function of the poet by rejecting a poetic diction that no longer had power to move the reader, so the Brotherhood sought to replace the exhausted artistic conventions that, passed down from Raphael and attenuated by the Academy, no longer had the power to convey to the audience the idea of the sacred. Like Wordsworth's new poetic language, the new art language of the Brotherhood was to be rooted in the common experience of men, in their ability to perceive the visible world as it actually exists. [5]

The effort to describe scriptural events in this new language so as to restore an intense awareness both of their historicity and of their sacredness was central to the Brotherhood. Hunt provides a clear statement of this aim in the 1846 conversation with Millais that he saw as marking the beginning of the Brotherhood:

> The language they used was then a living one, now it is dead. . . . In the figure of the risen Lord, for instance, about which we began to talk, the painters put a flag in His hands to represent His victory over Death: their public had been taught that this adjunct was a part of the alphabet of their faith. . . . If I were to put a flag with a cross on it in Christ's hand, the art-galvanising revivalists might be pleased, but unaffected people would regard the work as having no living interest for them. I have been trying for some treatment that might make them see this Christ with something of the surprise that the Maries themselves felt on meeting Him as One who has come out of the grave." (Hunt, 1:84–85)

Hunt started to carry out this plan with a historical treatment of Christ newly risen, *Christ and the Two Marys*, begun in 1847. Although he anticipated his later methods by painting the palm trees at the right from a specimen in Kew Gardens, the work gave him trouble; the classical massiveness of the kneeling Mary and the generalized landscape suggest that in 1847 Hunt had not completely shed the Raphaelite manner. The painting was not completed until the end of the century when Hunt finished the Christ and, now familiar with the Holy Land, painted in the geology of the mountains of Moab in the background.

The Carpenter's Shop exemplifies this effort to use stylistic innovation to present the life of Christ with freshness and vividness. Certainly, the intense attack by critics indicates that this picture, like other Brotherhood works, did genuinely diverge from mid-Victorian visual expectations. Although the language of their criticism is vague, its unanimity is significant. All the critics express their sense that the people appear deformed. To

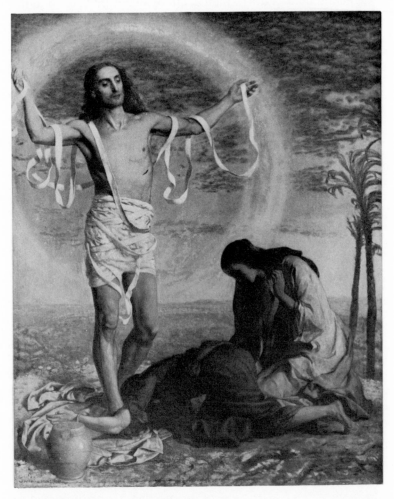

PLATE 6. Holman Hunt, *Christ and the Two Marys*. Reproduced by permission of
The Art Gallery of South Australia.

the *Art-Journal*, the painting is seen as "distorting the body."[6] To
Blackwood's, "emaciation and deformity constitute their chief
stock in trade. They apparently select bad models, and then
exaggerate their badness till it is out of all nature."[7] And to the
Athenaeum, it seems "difficult in the present day of improved
taste and information to apprehend any large worship of an
Art-idol set up with visible deformity as its attribute."[8] These
comments suggest how deep "Raphaelite" visual expectations
were. *Tait's Edinburgh Magazine* sets forth as the "highest perfec-
tion" in art Raphael's cartoon of "Paul Preaching at Athens." To
this reviewer, "there is no historical evidence that the apostles
bore any outward indication in their forms or faces of their divine
mission, yet how offensive, how monstrous, would be the error
of that artist who should seek the fitting type of St. Paul in a
common sailmaker or of St. Peter in a fisherman! The duty of the
painter when he deals with these subjects is, to give material
form and colour, to render palpable to the outward sense the
image created in the mind by the grandest and holiest associa-
tions." With this idealized, nonhistorical treatment of biblical
material as his model, the reviewer perceives the figure of Jesus
as "unhealthy."[9]

The intensity of the attack on *The Carpenter's Shop*, so puzzling
to modern critics, emerges, in part, from the reviewers' quite
accurate perception that these genuine divergences from artistic
decorum were signs of a more general attack on the entire model
of art history and theory maintained by the Royal Academy. The
reviews are less concerned with the individual work than with
the dangerous principles of the group as a whole. The *Athenaeum*
speaks of "the doings of a school of artists whose younger
members unconsciously write its condemnation in the very title
which they adopt—that of pre-Raffaellite:—and we would not
have troubled ourselves or our readers with any further remarks
on the subject, were it not that eccentricities of any kind have a
sort of seduction for minds that are intellectual without belong-
ing to the better orders of intellect."[10] The reviewers focus on the
challenge of the Brotherhood to the received belief that, in the
manner of a science, visual art in the Renaissance made certain
discoveries, such as the use of perspective, that culminated in
the Grand Style of Raphael and Michaelangelo, a style that the
artists of succeeding generations have been emulating. As the
reviewers recognize, admiration of the "pre-Raffaellite" implies
a subversive primitivism that sees premodern art as exhibiting a
vitality that has been destroyed by the techniques used from the
Renaissance to the present day. The *Athenaeum* speaks of the

Brotherhood as "setting at nought all the advanced principles of light and shade,"[11] the *Spectator* of going back "not to the perfect schools, but through and beyond them to the days of puerile crudity,"[12] the *Art-Journal* of returning to the "time when Art was employed in mortification of the flesh,"[13] and *Blackwood's* of "renouncing, in fact, the progress that since then has been made; rejecting the experience of centuries, to revert to models, not to art in its prime, but to art in its uncultivated infancy."[14] Dickens entitles his attack on the painting "Old Lamps for New Ones" and sees the group as the emblem of "the great retrogressive principle" that will demand not only a "Pre-Perspective Brotherhood" but even a "Pre-Newtonian Brotherhood" that might object to the laws of gravitation.[15]

The intensity of the attack on *The Carpenter's Shop*, then, dramatizes the atmosphere of artistic dissent generated by the Brotherhood effort to restore what they considered to be the authentic tradition of sacred art. But such a stance of opposition was inevitable. The modern religious artist, the members of Brotherhood in the nineteenth century or Rouault in the twentieth, must replace a visual language that has become drained of intensity through familiarity, and he can restore the sense of sacredness to art only by creating new styles, new modes of presenting traditional subjects. Only through such innovation can orthodox truths be presented freshly and intensely to the religious imagination. But such innovation inevitably opened the Brotherhood, all their orthodoxy of content and didacticism of purpose notwithstanding, to charges of "desecration"[16] and "blasphemy"[17] for violating the received ways of representing the divine. The historical irony—that at mid-nineteenth century religious purposes demanded rejection of the artistic tradition offered by established institutions—does much to explain how the Brotherhood effort to revive sacramental art gave rise to avant-garde movements later in the century. Once the religious motivations dissolved, the sense of opposition remained, to be passed on through Rossetti to Morris, Swinburne, and the aesthetic movement.

The reviewers' intense sense of the dangerousness of Millais's painting also indicates the degree to which Brotherhood style, as well as the immediate reaction against it, drew energy from notions not only of aesthetics but of social class. The most evident stylistic divergence of *The Carpenter's Shop* is its violation of Raphaelite decorum in treating a high biblical subject in the particularized style that the Victorians saw as more appropriate to representations of lower-class life, such as Dutch genre

scenes. Millais is here fulfilling Carlyle's call for a "Biography" (*Sartor*, 224) of Jesus, a historicist treatment that would, in the words Hunt attributes to Carlyle, "provide a veritable contemporary representation of Jesus Christ, showing Him as He walked about" (Hunt, 1:356). But the result of this break with Raphaelite practice is to shift Jesus' social class, to transform him from a person of high station into a worker actively engaged in making a living within the family shop.

Two years after the 1848 revolutions, these democratic implications were not lost on the reviewers. They saw that by rejecting a style that implicitly presented Jesus as a hero of high degree, Millais identified Jesus with the working class of their city, with an "unwashed brat, scratching itself against rusty nails in a carpenter's shop in the Seven Dials."[18] In this context, Dickens's well-known condemnation of Jesus as a "hideous, wry-necked, blubbering . . . boy, in a bed-gown" and Mary as "so horrible in her ugliness that . . . she would stand out from the rest of the company as a Monster, in the vilest cabaret in France, or the lowest gin-shop in England"[19] indicates not the eccentricities of genius but the representative middle-class sensibility he brought to the unaccustomed role of art critic. In part, since his visual model is Hogarth's *Gin Lane*, Dickens is articulating his sense that the methods of detailed realism are more appropriate to depictions of tavern scenes. But, like other bourgeois critics, Dickens, conveniently forgetting the New Testament narrative, cannot accept the association of Jesus with the inhabitants of "the vilest cabaret" or "lowest gin-shop." For other critics, outrage at the association of Jesus with the working class was expressed through religious terminology; the work is "heretical and damnable,"[20] a "pictorial blasphemy."[21]

The Carpenter's Shop also exemplifies a popular subject of the time, the childhood of Jesus,[22] a subject that particularly appealed to the Brotherhood because it so readily lent itself to typological treatment. Original scenes could be invented, treated with historical and naturalistic accuracy, and yet easily achieve religious meaning as prefiguring the later life of Christ. The second volume of *The Germ* begins with an illustrated poem by James Collinson, entitled "The Child Jesus." Both drawing and poem are explicitly figural.[23] The poem has as its subtitle "A Record typical of the five Sorrowful Mysteries" and, like *The Carpenter's Shop*, an Old Testament epigraph to suggest the need for typological interpretation. The five parts of the poem create a series of historically possible incidents in Jesus' childhood that are "typical" in being prefigurations of later events in His life.

PLATE 7. James Collinson, *The Child Jesus*. From *The Germ*, no. 2 (February 1850), Frontispiece.

For example, in part one, "The Agony in the Garden," the young Jesus sees his pet dove attacked and killed by a hawk.

The frontispiece of volume two of *The Germ* illustrates the third stanza in which, as a type of "The Crowning with Thorns," a group of Jesus' playmates place on his head a "wreath / Of hawthorn flowers" (*Germ*, 53). More than Millais, Collinson here has difficulty fully integrating natural detail into the symbolic scheme. The shells, the marine animals, the seaweed-covered rocks in the foreground would do credit to Philip Gosse in their detail and clarity of outline (plate 1); yet, without clear correspondence to iconographic conventions, they remain merely isolated physical objects. Unlike Millais, Collinson is unable to invent an incident that would draw even a large portion of his carefully detailed natural fact into a symbolic configuration. Whereas the poem remains consistent with the domestic life of the young Jesus, Collinson can find a visual equivalent for the poem only by violating its "typical" quality through the introduction of supernatural symbolic apparatus. Jesus is given a halo, and the cross in his hand carries a banner reading "Ecce Agnus Dei." With the use of these non-naturalistic elements, the work loses any of the sense of surprise and of interest that derive from the illusion of witnessing an actual scene in the childhood of a historically real Jesus.

Millais's other scriptural painting of his Brotherhood period, *The Return of the Dove to the Ark* (R.A., 1851), illustrates a variation of the Brotherhood desire to create a new typological art-language for Scripture. The theory behind such a work is best described by William Rossetti, who notes in "The Externals of Sacred Art" that for the culture of Victorian England, in which the defining qualities are "naturalism" and "Protestantism," the public is predisposed to "receive gladly any conscientious and heartfelt representation of Scriptural history, in which the aim is to adhere strictly to the recorded fact, merely transferring it from verbal expression to form, and depending for its impressive enforcement upon the fidelity of the transfer" (*Fine Art*, 42). The detailed accuracy shown in the handling of the individual stalks of hay and what Ruskin praised as the "ruffling of the plumage of the wearied dove" (12:235), as well as the rejection of idealization through the coarse features and ungainly posture of the daughters, enforces the historical actuality and particularly the domestic quality of biblical events. By illustrating an event recorded in Scripture rather than by inventing a wholly original scene, and by selecting an event whose typological significance in prefiguring the New Covenant is evident, Millais here suc-

PLATE 8. John E. Millais, *The Return of the Dove to the Ark*. Courtesy of the Ashmolean Museum, Oxford.

ceeds in fusing historical truth with sacred meaning, in directly "transferring" the figural quality of Scripture "from verbal expression to form."

During his Brotherhood period, Rossetti, too, devoted a good part of his effort to scriptural subjects. In their conception, these works conform to Brotherhood theory; Rossetti even hoped to accompany Hunt on a proposed journey to the Holy Land in 1850 (*PRBJ,* 73). And yet, filtered through Rossetti's distinctly non-naturalistic imagination, Brotherhood figuralism takes a distinctive form. Working outside Protestant tradition, Rossetti creates scriptural works that take on a medieval, hieratic quality.

His first completed painting, *The Girlhood of Mary Virgin* (1849, no. 40), was conceived within the Brotherhood aesthetic. In a significant letter of 1848 describing his aims, Rossetti, like the writers of *The Germ,* criticizes Raphaelite treatments of this subject for failing in historical accuracy. Such works are "very inadequate" since "they have invariably represented her as reading from a book under the superintendence of her Mother, St. Anne, an occupation obviously incompatible with these times, and which could only pass muster if treated in a purely symbolical manner" (*Letters,* 1:48). Rather than working in a "purely symbolical manner," Rossetti seeks to create a scene both freshly original and compatible with historical fact: "In order, therefore, to attempt something more probable and at the same time less commonplace, I have represented the future Mother of Our Lord as occupied in embroidering a lily,—always under the direction of St. Anne" (*Letters,* 1:48). Although it is scarcely less "incompatible" to have the Virgin working at embroidery rather than reading a book, Rossetti's intentions are clear: to convey the figural quality of the Virgin's Life by showing such traditional signs as the lily as both symbol and domestic fact. In similar fashion, other symbols are absorbed into the daily reality of household life, notably the Cross, which forms a trellis for the ivy, the True Vine being pruned by Saint Joachim, and the Robe of Christ, which becomes the red cloth in the center. Even the modeling of the Virgin and of Saint Anne from his sister and his mother indicate his desire to fuse the sacred with the domestic.

Yet, Rossetti's stated aim of creating a scriptural work "more probable and . . . less commonplace" by applying historical methods to a traditional subject remains unfulfilled in the finished work. The first painting to exhibit the initials "P.R.B." shows how uncongenial the group's aim of historical accuracy, indeed, how uncongenial any thoroughgoing naturalism, was to

PLATE 9. D. G. Rossetti, *The Girlhood of Mary Virgin* (no. 40). The Tate Gallery, London.

his imagination. Unlike Millais's dove in *The Carpenter's Shop*, this dove, whose prefigurative meaning is identical, is given a nimbus; Mary and Saint Anne are each given a halo. Such objects as the angel watering the lily or the six volumes bearing the names of the virtues violate the naturalistic premise. As in Collinson's work, mottoes appear within the work itself—the briar and the palm in the foreground bear the inscription, "Tot dolores tot gaudia"—rather than, as in the work of Millais and Hunt, as glosses that frame a naturalistic representation.

With the subversive implications of the initials "P.R.B." yet unknown, the medievalizing quality of the work attracted favorable notice. The *Art-Journal* noted, "The artist has worked in austere cultivation of all the virtues of the ancient fathers."[24] And the *Athenaeum* approved the painting as one "in which Art is made the exponent of some high aim, and what is 'of the earth earthy' and of the art material is lost sight of in dignified and intellectual purpose."[25]

Curiously, without knowing the meaning of the initials on the painting, the reviewers praise the work for its "Pre-Raphaelite" quality, for its imitation of the same early-Renaissance artists that the members of the Brotherhood believed themselves to be emulating. To the *Art-Journal*, Rossetti's painting is "successful as a pure imitation of early Florentine art. . . . With all the severities of the Giotteschi, we find necessarily the advances made by Pietro della Francesca and Paolo Uccello." The reviewer for the *Athenaeum* is reminded "of the feeling with which the early Florentine monastic painters wrought; and the form and face of the Virgin recall the works employed by Savonarola. . . . Mr. Rossetti has perhaps unknowingly entered into the feelings of the renowned Dominican who in his day wrought as much reform in art as in morals." And the *Observer* sees the painting as "partaking of the hard manner of the period of Italian art which preceded Raffaelle."[26] The *Art-Journal* is quite exact in giving the stylistic elements that make the painting appear Pre-Raphaelite: "There is no shade in the picture, the figures being rounded by gradations jealous of the slightest approach to depth. The expression and character of the features are intense and vivacious, and these, together with the draperies and accessories, are elaborated into the highest degree of nicety." These remarks suggest that in 1849 there was a constellation of stylistic elements—lack of chiaroscuro, hard-edge modeling, flatness of picture plane, clear detailing of secondary objects—that both Rossetti's circle and the Victorian public would call "Pre-Raphaelite." Furthermore, the uniform praise of this first paint-

ing suggests that these particular stylistic elements were not in themselves revolutionary, particularly when used in a work perceived as an imitation of an earlier style.

Rossetti's next painting, *Ecce Ancilla Domini!* (1850, no. 44), more nearly achieves the figural aims of the Brotherhood to create not merely the most successful Brotherhood religious painting but one of the most lastingly attractive works of Victorian art. In its conception, the work rejects the traditional idealized treatment of the Annunciation to represent an event occurring at a particular moment and place within historical time. As William Rossetti noted in 1849 of the first sketch of the work, "The Virgin is to be in bed, but without any bedclothes on, an arrangement which may be justified in consideration of the hot climate" (*PRBJ*, 29). Of poor family, the Virgin is simply clad, and the brilliant use of an awkward, shrinking posture enclosed by the angles of the wall conveys a historically real individual understandably withdrawing from an awesome responsibility.

The ascetic spareness of the scene, again historically consistent with the Virgin's social class, does much to resolve the formal difficulties in presenting fact as figure. Rossetti's imagination shuns the obsession with the overwhelming plenitude of the physical world, with the multitudinous detail that his colleagues could not endow fully with sacramental meaning. Instead, Rossetti shows a sparsely furnished room in which almost every household object, the lighted lamp and the completed lily embroidery, for example, can be read as figuring the blending of divine and human in the central event.

These two early paintings were originally conceived within a larger scheme, as part of a triptych whose formal principle is distinctly typological. In the first of the sonnets attached to the original frame of *The Girlhood*, Rossetti so accurately describes his Annunciation—"Till one dawn, at home, / She woke in her white bed"—as to indicate that he already had this second painting in mind. To indicate the way in which the events of the second are prefigured by the first, he shows in the *Ecce Ancilla* the lily embroidery of *The Girlhood* now completed. If he had carried out his original intentions, he would have accompanied the Annunciation with a third piece, "its companion of the Virgin's Death" (*PRBJ*, 29), so that the *Ecce Ancilla* as well as *The Girlhood* would have been seen as prefiguring the mission and the death of Mary within historical time.

Of the two sonnets attached to *The Girlhood* on its exhibition, the whole of the second ("These are the symbols") and the octet of the first ("This is that blessed Mary") are stylistically analo-

PLATE 10. D. G. Rossetti, *Ecce Ancilla Domini!* (no. 44). The Tate Gallery, London.

gous to the medieval, ahistorical quality of the painting.[27] The opening lines of the first—"This is that blessed Mary, pre-elect / God's Virgin"—describe a Mary beyond historical time, with the opening word "This" stressing her function as icon. The octet becomes a litany; echoing the "Hail Mary," it numbers her virtues in an abstract diction, with the omission of the verb emphasizing existence beyond the realm of human action:

> From her mother's knee
> Faithful and hopeful; wise in charity;
> Strong in grave peace; in duty circumspect.

But as the sestet of this first sonnet shifts to describing the more historical conception for the Annunciation, the poetic style shifts from the iconic to the historical and psychological mode of the *Ecce Ancilla*:

> So held she through her girlhood; as it were
> An angel-watered lily, that near God
> Grows, and is quiet.

The word *grows* transforms the traditional sign of the lily into a metaphor for human development within historical time. "Till one dawn at home" places the action at a particular moment and a specific place. As in the *Ecce Ancilla*, Rossetti's imagination characteristically focuses on states of consciousness, on how the historical Mary "felt": "She woke in her white bed, and had no fear / At all,—yet wept till sunshine, and felt awed." Even the final line, "Because the fulness of the time was come," refers to the fusion of the sacred and the personal, suggesting both the physical fact of Mary as now bearing Jesus and that this physical change fulfills patterns beyond time.

This same occupation with the historical Mary marks his Brotherhood drawing of *The Virgin Mary Being Comforted* (1852, no. 51) and of *The Maries at the Foot of the Cross* (1852, no. 52), as well as his major Brotherhood poem on a scriptural subject, "Ave." The 1870 text of this poem grew from a pre-Brotherhood poem, "Mater Pulchrae Delectionis," of 1847 (*Works*, DGR, 661–62), a medievalizing poem intended for "Songs of the Art Catholic" and giving an iconic presentation of the enthroned Virgin adored by angels. According to William Michael Rossetti, between 1847 and 1869 the poem "was subjected to a great deal of alteration" (*Works*, DGR, 661), alteration that consists primarily of the addition of material emphasizing the historical and the psychological. Perhaps it is because the poem represents so well his earlier Brotherhood manner that, according to his brother,

Rossetti "rather hesitated about including" the revised poem in the collection of 1870 (*Works,* DGR, 661).

Only the opening and concluding sections of the 1870 text retain the manner of the original poem. The opening stanza shows the Virgin as icon:

> Mother of the Fair Delight,
> Thou handmaid perfect in God's sight,
> Now sitting fourth beside the Three,
> Thyself a woman-Trinity.
>
> (1–4)

The second section, however, moves into historical time in the empathic mode shown in the poems on *The Girlhood* and in the *Ecce Ancilla* itself. Seeking what he calls in a note on the poem "an inner standing-point" (*Works,* DGR, 661), he enters the consciousness of Mary at the Annunciation to evoke through a metaphoric diction the inward experience of the sacred:

> Until a folding sense, like prayer,
> Which is, as God is, everywhere,
> Gathered about thee; and a voice
> Spake to thee without any noise,
> Being of the silence.
>
> (26–30)

The other historical events that Rossetti adds to the original text, such as the eating of the Passover, are clearly prefigurative; but his occupation is consistently with the emotive, the way in which this young girl responded inwardly to the sacred quality of her daily life:

> And through His boyhood, year by year
> Eating with Him the Passover,
> Didst thou discern confusedly
> That holier sacrament, when He,
> The bitter cup about to quaff,
> Should break the bread and eat thereof?
>
> (38–43)

The resolution of the poem comes with the recognition that Mary's life was indeed psychologically different from our own, that she did indeed feel the divinity informing her domestic round:

> Work and play,
> Things common to the course of day,
> Awed thee with meanings unfulfill'd.
>
> (50–53)

Only in the final stanza does the poem leave the temporal Mary to return to a medievalized picture of the Heavenly Mary:

Unto the left, unto the right,
The cherubim, succinct, conjoint,
Float inward to a golden point,
And from between the seraphim
The glory issues for a hymn.

(101–5)

Like the first, this final stanza defines the essentially pictorial form in which icons of Mary outside of time frame a series of figural events in her earthly life.

The historical incidents that form the center sections of "Ave" are also the subject of an unexecuted triptych conceived by Rossetti in 1849 as illustrating the prefigurative continuity of Mary's life. Rossetti envisioned "two side-pieces," one of the "Virgin planting a lily and a rose" ("Ave," 14–22), the other of the "Virgin in St. John's house after the crucifixion" ("Ave," 64–68) (*PRBJ*, 13). For the "middle compartment," to "represent her during his life," he thought of "the eating of the passover by the Holy Family" (*PRBJ*, 13). Sketches for each panel were presumably made, but those of the two side panels have been lost. We have only their completed form in, respectively, *Mary Nazarene* (1857, no. 87) and *Mary in the House of St. John* (1858, no. 110).[28] Only the original design for the middle compartment survives (no. 78A). The figural scheme for this study of the Holy Family gathering bitter herbs is best described in Rossetti's own words: "The scene is in the house porch, where Christ (as a boy) holds a bowl of blood from which Zacharias is sprinkling the posts and lintel. Joseph has brought the lamb and Elizabeth lights the pyre. The shoes which John fastens, and the bitter herbs which Mary is gathering, form part of the ritual."[29] Other prefigurative elements include the cruciform structure of the porch and the table set for the Passover meal with wine and unleavened bread.

In 1854, Ruskin saw the design and commissioned a water color from it. The completed work, *The Passover in the Holy Family: Gathering Bitter Herbs* (1855–56, no. 78), continues the typological conception, only substituting for the lamb and pyre a well with a cruciform support. But as Rossetti worked on the commission, there was much discussion of the project within his circle. Coventry Patmore wrote to Rossetti in 1855 that the "symbolism is too remote and unobvious to strike *me* as effective" (*RRP*, 139). In a supportive note to Rossetti, Ruskin praised the historical treatment: "Patmore is very nice; but what does he mean by Symbolism? I call that Passover plain prosy Fact. No symbolism at all" (*RRP*, 140). Rossetti's reply indicates not only

[67]

PLATE 11. D. G. Rossetti, design for *The Passover in the Holy Family: Gathering Bitter Herbs* (no. 78A).

his clear typological intentions but also his willingness to defend such aims well into the 1850s. For Rossetti, the chief merit of his scheme is its historicity, its existence, in Ruskin's words, as "plain prosy Fact": "Its chief claim to interest, if successful when complete, would be a subject which must have actually occurred during every year of the life led by the Holy Family, and which I think must bear its meaning broadly and instantly—not as you say 'remotely'—on the very face of it,—in the one sacrifice really typical of the other" (Letters, 1:276). In showing a historical event that must have occurred rather than an invented episode that might have occurred and, furthermore, an event whose typological meaning is so traditional as to be "broadly and instantly" available, the work is, for Rossetti, superior even to Millais's Carpenter's Shop: "In this respect—its actuality as an incident no less than as a scriptural type—I think you will acknowledge it differs entirely from Herbert's[30] some years back, Millais' more recently . . . not one of which . . . is anything more than an entire and often trifling fancy of the painter, in which the symbolism is not really inherent in the fact, but merely suggested or suggestible, and having had the fact made to fit it" (Letters, 1:276). As Rossetti notes in the opening lines of the poem accompanying the water color, "Here meet together the prefiguring day / And day prefigured."

1. This quality of participation in Brotherhood work is emphasized in Stein, The Ritual of Interpretation, chap. 5.

2. In The Finer Optic, Christ discusses the relationship of Brotherhood style to sacramentalism, pp. 60–61.

3. John Rylands Library, Manchester, Eng. Ms. 1216, f. 31.

4. Art-Journal n.s. 2 (1 June 1850): 175.

5. The British Quarterly Review 16 (August 1852): 197–220, one of the most intelligent contemporary accounts of the Brotherhood, notes the relationship to Wordsworth.

6. Art-Journal n.s. 2 (1 June 1850): 175.

7. Blackwood's 68 (July 1850): 82.

8. Athenaeum, No. 1179 (1 June 1850), p. 590.

9. Tait's Edinburgh Magazine 18 (August 1851): 512.

10. Athenaeum, No. 1179 (1 June 1850), pp. 590–91.

11. Athenaeum, No. 1173 (20 April 1850), p. 424.

12. Spectator 23 (4 May 1850): 427.

13. Art-Journal n.s. 2 (1 June 1850): 175.

14. Blackwood's 68 (July 1850): 82.

15. Household Words 1 (15 June 1850): 266.

16. Ibid.

17. *Athenaeum,* No. 1179 (1 June 1850), p. 591.

18. *Tait's Edinburgh Magazine* 18 (August 1851): 512.

19. *Household Words* 1 (15 June 1850): 265–66.

20. *Tait's Edinburgh Magazine,* loc. cit.

21. *Athenaeum,* No. 1179 (1 June 1850), p. 591.

22. See T. S. R. Boase, *English Art, 1800–1870* (Oxford: Clarendon Press, 1959), p. 282. Boase mentions and illustrates J. R. Herbert's *Our Saviour subject to His Parents at Nazareth* (1847).

23.See Ian Fletcher, "Some Types and Emblems in Victorian Poetry," *Listener* 78 (25 May 1967): 679–81.

24. *Art-Journal* n.s. 1 (May 1849): 147.

25. *Athenaeum,* No. 1119 (7 April 1849), p. 362.

26. *Observer* (8 and 9 April 1849). Quoted in S. N. Ghose, *Dante Gabriel Rossetti and Contemporary Criticism (1849–1882)* (Dijon: Imprimerie Darantière, 1929), p. 24.

27. The text here is that of the sonnets originally affixed to *The Girlhood* (Surtees, 1: 10–11).

28. See D. M. R. Bentley, "Rossetti's 'Ave' and Related Pictures," for fuller discussion of these post-Brotherhood works.

29. Mariller, p. 68. Mariller also reproduces this work.

30. J. R. Herbert, *Our Saviour subject to His Parents at Nazareth* (1847). See n. 22.

HISTORY AS SCRIPTURE

 At the Royal Academy Exhibition of 1850, Millais's *Carpenter's Shop* was hung directly above Hunt's entry, *A Converted British Family sheltering a Christian Priest from the Persecution of the Druids*. This physical juxtaposition indicates their theoretic continuity. If *The Carpenter's Shop* shows the typical quality of domestic events in the life of the holy family, Hunt's painting suggests the equally typical quality of events after the time of Christ. And if Millais's work derives from Ruskin's suggestions in *Modern Painters* II for a new biblical art, Hunt's painting continues the efforts of both Ruskin and Carlyle as historians to show that human history after the time of Christ continues to follow providential patterns. More specifically, *A Converted British Family* presents a visual analogue to *Past and Present* in using correspondences to traditional iconography in order to suggest that the history of England follows the sacred purposes figured in the scriptural narrative.

Like Carlyle, and like Millais, Hunt works in an intensely historicist mode. Quite self-consciously, Hunt saw his archaeological methods as manifesting the true spirit of his own age: "Antiquarianism in its historic sense . . . made thus a radical distinction between all illustrations by the old masters and those of modern art; to the former the costume, the type of features, and architecture were the same whether the subject were in ancient Egypt or imperial Rome. When a modern artist, influenced by the new learning, had settled upon a subject . . . his further consideration was what character of costume and accessories it would require; he worked thus to give discriminating truth to his representation" (Hunt, 1:176). His description of the painting sent to Thomas Combe, its first owner, indicates Hunt's concern with maintaining historical probability.[1] To defend himself against criticism that the work "had been designed in disregard to historical evidence," he argues in a convoluted fashion that the "druidical system" had been subject to the work of Christian missionaries in the first century, the date of the painting. He also asserts that the objects in the painting are not introduced merely for their symbolic reference, but are historically consistent. The vine is not an "anachronism," but "more

[71]

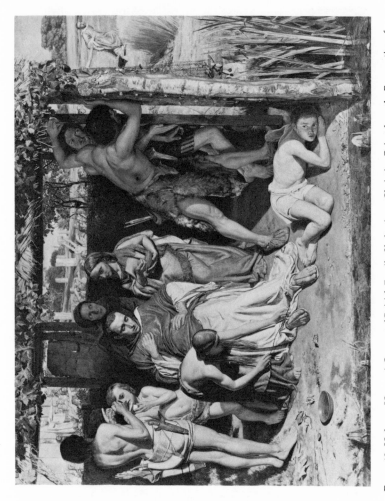

PLATE 12. Holman Hunt, *A Converted British Family Sheltering a Christian Priest from the Persecution of the Druids*. Courtesy of the Ashmolean Museum, Oxford.

than probable" as having been introduced from Gaul. As in other Brotherhood works, form emphasizes historicity. As in *The Carpenter's Shop*, a three-sided room is used to give the viewer the sense of being an unobserved witness to an actual event. The landscape was painted out-of-doors at an actual marsh, and such objects as the beech-column supporting the shed were painted from actual specimens.

Within Hunt's scheme, this historical accuracy becomes not an end in itself but a means of demonstrating providence continuing to act within human history even after the Incarnation. In his remarks to Combe, Hunt is explicit about the fusion of historicism with religious purpose through the figural mode: "Thus it was certainly possible for the incident to have occurred, and so that it does not contend with history, and it is a fulfilment of the texts quoted in connection with the picture, and others in which the persecutions to which the disciples were subjected are prefigured."* The scriptural quotations on the frame, then, urge the viewer to read the painting in as typological a manner as he would the events of Scripture, to see the events in the Bible of history as fulfilling patterns prefigured in the time of Christ. And the painting itself emphasizes this parallel between the difficulties encountered by the early missionaries to England and the persecution of Christ and His Disciples. In his account to Combe, Hunt explains that the missionaries, having converted at least one "aboriginal family," have gone to the "druidical temple to make known the Lord publically." In the background, the druid priest, a type of the Jewish opponents of Jesus, stands at the temple exhorting his people to capture the missionary of the new religion. In the foreground, the rescued priest is being sheltered by his disciples, who are fishermen.

This continuance of eternal patterns through historical time is reinforced by correspondences between traditional iconography and events within the converted family's household. A girl removes from the priest's robe a thorn that has pierced his feet. The young boy on the left is dressed in a fur loincloth, the traditional sign of John the Baptist, and, like the similarly dressed figure in *The Carpenter's Shop*, offers a healing liquid, the juice of freshly squeezed grapes. Another girl wipes the priest's face with a sponge. Other allusions are purely formal;

*On the original frame were inscribed the texts, "The time cometh, that whosoever killeth you will think he doeth God a service / Their feet are swift to shed blood / For whosoever shall give you a cup of water to drink in my name, because you belong to Christ, verily I say to you, he shall not lose his reward / I was a stranger and ye took me in."

the slumping priest backed by an older and a younger woman assumes the pose of a Pietà. It is most likely such evident visual parallels that Hunt, in his note to Combe, considers as having a meaning "too simple and evident to require pointing out." Yet he is emphatic in noting that reference to such traditional symbols is consistent with the painting as historical narrative: "They in no wise interfere with the dramatic unity of the design."

Of this picture, Hunt said in 1855, "I would as soon rely on that to express my idea of Pre-Raphaelitism as any picture I ever painted."[2] He is correct, but for reasons that he does not acknowledge. In history painting, as in biblical painting, the effort to combine historical accuracy with sacred significance leads toward obscurity and private meaning. Like Millais in *The Carpenter's Shop,* Hunt seeks to create the feeling of historicity by presenting the multitudinous detail of any directly observed event. To Hunt's authentically figural imagination, these separate facts each bear a sacred meaning; but, as in the biblical companion piece, such significance can be conveyed only by correspondence to traditional iconography. Material outside this scheme of correspondences remains opaque, and Hunt here is forced to communicate the full range of his sacred vision not through the canvas itself but through a separate verbal gloss. The exegesis sent to Combe reveals a highly private set of symbolic meanings. Hunt notes, for example, that the vine and corn, which he is at great pains to justify on historical grounds, were introduced "to exhibit the civilizing effect of the divine religion which the missionaries had taught to the occupiers of the hut." Or he states of the net hanging at the corner of the shed that it is "suggestive of Christianity from two causes, first, as being a figure under which the Christian Church is typified in the Scriptures, and, again, from the fact that the Druids held fish to be sacred and forbade the catching of them."

In the Royal Academy Exhibition of the previous year, Hunt had exhibited another painting that illustrates equally well the Brotherhood effort to show divine purpose in postbiblical history. *Rienzi vowing to obtain justice for the death of his young brother, slain in a skirmish between the Colonna and the Orsini factions* (R.A., 1849) is, in one sense, a literary painting since it illustrates a scene from Bulwer-Lytton's *Rienzi, The Last of the Tribunes,* first published in 1835 but reissued in 1848 with a new preface that stressed its topical relation to the revolutions in Italy. Hunt was drawn to the work for its use of the literary-historical mode. Drawing upon the same impulses of the 1830s

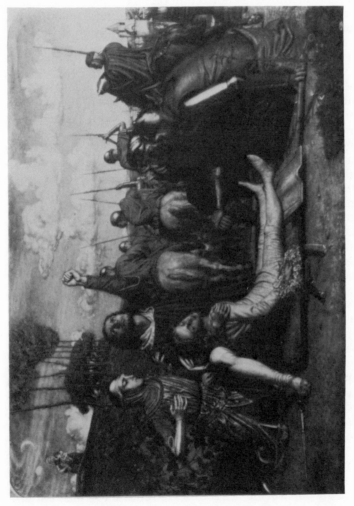

PLATE 13. Holman Hunt, *Rienzi vowing to obtain justice for the death of his young brother, slain in a skirmish between the Colonna and the Orsini factions*. Courtesy of Sotheby's Belgravia.

and 1840s as Carlyle and the Brotherhood, the novel purports to show the past as it actually occurred;[3] as Bulwer notes in the 1848 preface, "Its interest is rather drawn from a faithful narration of historical facts than from the inventions of fancy."[4] In characteristic Brotherhood fashion, Hunt prefers his history mediated through literature. Just as Brotherhood scriptural paintings are visual translations of events in the biblical narrative, so *Rienzi*, as history painting, presents an event described in a historical novel that claims to be a historical documentary. To set the work in a specific time and place in the past, Hunt did what he calls "research" for the costumes and for the architecture of the castle in the right background (Hunt, 1:115); the shield upon which the fallen brother lies and the spears of the retreating soldiers were drawn from specimens at the Tower of London.

For Bulwer, writing in the preface of 1848, the events of the Roman past described in the novel appear significant as prefiguring the present struggle for independence in Italy: "In preparing for the Press this edition of a work illustrative of the exertions of a Roman, in advance of his time, for the political freedom of his country, and of those struggles between contending principles, of which Italy was the most stirring field in the Middle Ages, it is not out of place or season to add a few sober words whether as a student of the Italian Past, or an observer, with some experience of the social elements of Italy as it now exists, upon the state of affairs in that country."[5] Hunt was attracted by the political message of the novel articulated in the 1848 preface, and saw his own canvas, as Bulwer did his novel, as a statement of support for the libertarian movements in Italy. Of the year 1848, when he moved within Italian émigré society at the Rossettis, Hunt says: "Like most young men, I was stirred by the spirit of freedom of the passing revolutionary time. The appeal to Heaven against the tyranny exercised over the poor and helpless seemed well fitted for pictorial treatment. 'How long, O Lord!' many bleeding souls were crying at that time" (Hunt, 1:114).[6]

The biblical allusions in Hunt's comment point to the sacramental scheme that underlies his "pictorial treatment" of Italian history. Bulwer's prefigurative reading of the Roman past was undoubtedly attractive to Hunt, but Bulwer's vision is secular in seeing the political life of a country as repeating similar patterns through historical time. Hunt's conception is sacramental; history is providential in continuously bodying forth the principles—here the divinely sent hero struggling for the oppressed—that are prefigured in Scripture. Within the canvas, the composition centers upon Rienzi with a constellation of

visual allusions—the dead youth with a fallen crown of flowers and surrounded by a mourning group resembling a Pietà, the mother holding a child in the far-left background with a crescent moon suggesting her association with the Virgin, two Roman soldiers observing the corpse—that, as in the *Converted British Family,* suggest a metaphysically real correspondence between the events of postbiblical history and the life of Christ. In its reference to the transcendent, then, the painting can be seen as a visual analogue to *Past and Present,* published only six years earlier, not only in its longing for the reappearance of a Christlike hero, but also in its use of figural form to comment upon contemporary revolutionary events.

Unlike Hunt, Millais had little interest in turning history painting into social commentary. Instead, his one painting of post-scriptural history executed during the Brotherhood period, *A Huguenot, on St. Bartholomew's Day, refusing to shield himself from danger by wearing the Roman Catholic badge* (R.A. 1852), illustrates how uncongenial the moralization of history was to his imagination. While working in the country on *Ophelia,* Millais had sketched a subject from Tennyson, an illustration of the line "Two lovers whispering by an orchard wall" from the poem "Circumstance" in the 1830 volume. Hunt wanted Millais to moralize the picture of two lovers by using a historical context to transform them into types of general ethical principles:

> Tennyson in the poem makes it merely a step in the progress of two honest lives; your illustration of "Two Lovers whispering by a Garden Wall" would have neither prelude nor sequel in the drama of life. It may be a crotchet of mine, but I have none but passing interest in pictures of lovers when they are merely this with no external interest. . . . I should have liked you to be engaged on a picture with the *dramatis personae* actuated by generous thought of a larger world. I think lovers with only personal interest should not be represented for public attention, even when they are not (as often they are) of sickly sentiment. (Hunt, 1:285)

Although, according to Hunt, Millais replied, "I understand your position now . . . I quite agree with you about maudlin sentiment" (Hunt, 1:285) and was later to say that "the subject . . . contains the highest moral,"[7] the divergence of the painting itself from Brotherhood principles indicates how minimally Hunt's idea of figural history controlled Millais's occupation with sentimentalized eroticism. Although rendered in the brick-by-brick manner of the Brotherhood, the wall appears only as a theatrical backdrop against which are posed the two lovers. There is little sense of an accidentally observed event. Similarly,

[77]

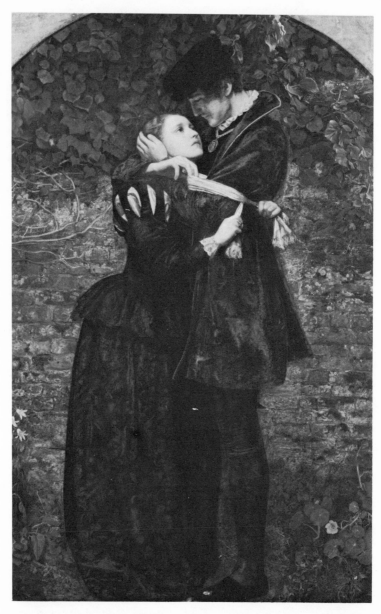

PLATE 14. John E. Millais, *A Huguenot, on St. Bartholomew's Day, refusing to shield himself from danger by wearing the Roman Catholic badge.* Courtesy of Christie's.

the abandonment of uniform illumination for a chiaroscuro focus on the girl's face, as well as the posing of the faces gazing at each other, draws attention inward to personal relationships rather than, as Hunt wanted, outward to public significance. With no correspondence between particularized details and iconographic traditions to connect this specific incident to time-less moral patterns, the historical treatment becomes mere costuming and the painting, as Hunt warned, a work of mere "sickly sentiment."

It is in the Academy entry of the next year, *The Order of Release, 1746* (R.A., 1853) that Millais's occupation with the easy evocation of feeling, as well as with his personal erotic concerns, finally breaks free from the constraints of figural methods. The divergence of this painting from Brotherhood principles was clear to contemporary viewers. The *Athenaeum* praised the painter for having "so completely escaped from the trammels of the school which he founded,"[8] while William Michael Rossetti spoke more in sorrow at Millais's apostasy: "In choice of subject and in some points of treatment, Mr. Millais has here met the opponents of Praeraphaelitism half-way; to his great gain in popular recognition, although not, as we think, to his own true progression" (*Fine Art*, 211–12).

As the critics perceived, the work differs from Brotherhood history painting in that its purpose is to evoke feeling, rather than figure the transcendent. Instead of the characteristic Brotherhood composition that, as in the *Huguenot*, orders the historical actors into moral conflict, such as between love and duty, this painting presents only the moment of resolution in the too easy victory of domestic virtue. Rather than stimulating moral thought, the painting calls up only a slosh of feeling. As William Michael Rossetti notes, it is this rejection of a typicality in which particularized historical action manifests timeless ethical principles that separates this work from true Brotherhood productions: "With all our admiration of the feeling of this picture, it appears to us to partake more of the sentimental, and by so much to derogate from the nobly universal tone of the Huguenot subject of last year" (*Fine Art*, 213).

"Paltering with the decried Praeraphaelite doctrine of absolute undeviating truth" (*Fine Art*, 212), Millais loses the detailed materiality that marks his Brotherhood manner. If in the *Huguenot* the minutely observed brick wall remains, if only as a backdrop, here walls have entirely vanished: "There is no background properly so called, but merely a laying of dark colour, which may be supposed to stand *instead of,* but cannot be admit-

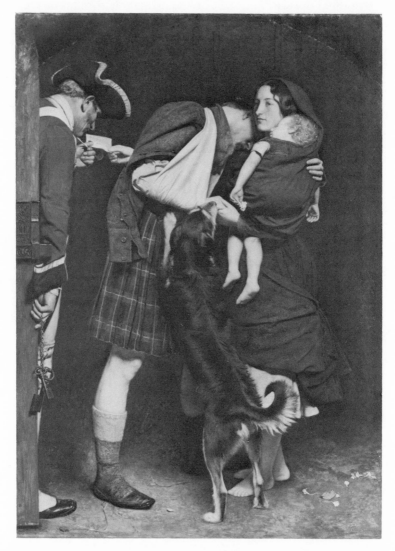

PLATE 15. John E. Millais, *The Order of Release, 1746*. The Tate Gallery, London.

ted to stand *for,* the shadowed prison-wall" (*Fine Art,* 212). The Brotherhood's historical, scientific manner dramatizes the severe principle that ethical choices must be made in the difficult, tangible world of fact. The theatricality of this work, its failure to place the domestic loyalty of the wife in the world of fact, then, shows the exercise of virtue as divorced from the daily experience of the viewer. This vitiation of ethical force in the painting only bears out the Ruskinian principle that in art moral truth depends upon visual truth.

As William Michael Rossetti caustically notes, "The wife's feet are preternaturally delicate and unsoiled for one who has been walking barefoot" (*Fine Art,* 213). With all suggestion of ugliness or dirt removed, the soldier's wife appears not as she might have in a Brotherhood treatment, a dignified member of the lower classes who figures the divine principle of fidelity, but exactly as what she is, Effie Gray Ruskin, a middle-class woman, posing in Highland dress. With the omission of any suggestion of the impoverished actuality of lower-cass life, the middle-class audience can freely allow themselves to be touched, for a moment, by the simple virtues of the idealized poor.

The sentimental form that brought the work great popularity coexists with a wholly private, perhaps unconscious, significance. When Effie Ruskin sat as model for the Highlander's wife through March of 1853, only a few months before the summer at Glenfinlas, Millais, who had already known the Ruskins for two years, must have already felt an attraction to this handsome, unhappy young woman. His rejection of his original title, *The Proscribed Royalist,* suggests how the painting could become the vehicle for erotic fantasy, a projection of his desire for an order of release from his own sexual constraints. The main figure, a muscular young man whose facial features are hidden, whose right arm is bound and impotent, and who can win release from imprisonment only through the exertions of a woman, appears to embody Millais's sense of his present condition. The physical union with the woman, cast into a domestic tableau including child and faithful dog, might be said to anticipate, even to prefigure, the conventional domestic life finally achieved by Millais and Effie.

Historical subjects set in moments of political and social crisis held no attraction for Rossetti. With the exception of his illustrations of Dante, his treatments of life after the time of Christ focus on the present. Here, his artistic sources are not the early Italians but the Flemish painters Hans Memling and Jan Van Eyck that he and Hunt so admired on their 1849 trip to the low countries.

[81]

His major Brotherhood poem on a genre subject, "My Sister's Sleep," as printed under the heading "Songs of One Household, No. 1" in *The Germ*, draws upon, in particular, Van Eyck's *Arnolfini Wedding*, a work the Brothers knew in the National Gallery (*Letters*, 1:84), to suggest the fusion of the sacred and the domestic that occupied him in his treatment of the life of Mary.* William Michael Rossetti properly states of this poem that it demonstrates "in an eminent degree one of the influences which guided that [Pre-Raphaelite] movement: the intimate intertexture of a spiritual sense with a material form; small actualities made vocal of lofty meanings" (*D&W*, 127). As in "Ave," Rossetti suggests this sacramental quality of daily life by organizing the poem as a painting in which there is a visual correspondence between the precisely rendered domestic details and Christian iconography.[9]

As twelve strikes, bringing in Christmas morn, the mother rises, "Her needles, as she laid them down, / Met lightly" (10;8).[10] Within the pictorial conception, the needles on the table form a cross, just as in *The Girlhood* the domestic detail of the vine-covered trellis in the background is given this shape. The "candle" on her "work-table" (3;3) figures faith; the "mirror," in its "clearness' (5;5), an allusion to the *Arnolfini Wedding*, symbolizes virginal purity.[11] As the poem moves into Christmas morn, the scene is gradually composed into the traditional pictorial configuration of an Adoration. The mother says, "Glory unto the Newly Born!" (11;9) and the brother silently repeats the words. The speaker then notes, "Just then in the room over us / There was a pushing back of chairs" (14;10). As consistent as this detail may be with the crowded life of urban tenements, it also furthers the visual correspondence to an Adoration. Traditionally, angels are placed above, observing events in the manger below. In Rossetti's own Adoration, the center panel of the triptych *The Seed of David* (1858–64, no. 105) done for the Llandaff Cathedral, angels watch from a loft above the stable.

The final tableau shows the mother and brother kneeling before the child. If the mother is likened earlier to an angel providing the exclamation of joy at Christ's birth, "'Glory unto the Newly Born' / So, as said angels, she did say" (11;9), the brother, who has not yet achieved the religious vision of the mother, corresponds to the shepherd of the traditional scene. As in the Llandaff triptych, angel and shepherd, mother and

*The text of the *Germ* version is printed in Appendix 1.

PLATE 16. D. G. Rossetti, *The Seed of David* (no. 105). Reproduced by permission of the Dean and Chapter of Llandaff Cathedral.

brother kneel before the "newly born" (19;15), the Christ Child
in swaddling clothes, the sister dressed in "all white" (18;14).

Rossetti's desire to have the scene read typologically appears
in specific glosses within the *Germ* text. In stanzas seven and
eight, for example, the speaker gives an explicitly transcendental
explanation of the events:

> Silence was speaking at my side
> With an exceedingly clear voice:
> I knew the calm as of a choice
> Made in God for me, to abide.
>
> I said, "Full knowledge does not grieve:
> This which upon my spirit dwells
> Perhaps would have been sorrow else:
> But I am glad 'tis Christmas Eve."

Yet, these glosses that in the Brotherhood version evoke the
sacramental significance of domestic event were omitted when
Rossetti revised the poem for his 1870 edition. These post-
Brotherhood revisions, which clearly indicate Rossetti's "dis-
taste" (*Germ*, 18) for his youthful religious manner, primarily
operate to free the occupation with physical and mental sensa-
tion already present in the *Germ* version from the figural scheme.
To liberate these aesthetic qualities, Rossetti alters the essen-
tial mode of the poem from the pictorial and painterly to the
evocative and psychological. For example, stanza one in *The
Germ* reads:

> She fell asleep on Christmas Eve.
> Upon her eyes' most patient calms
> The lids were shut; her uplaid arms
> Covered her bosom, I believe.

For the 1870 edition, the stanza was changed to:

> She fell asleep on Christmas Eve:
> At length the long-ungranted shade
> Of weary eyelids overweigh'd
> The pain nought else might yet relieve.

If the first is a painter's representation of the sister as effigy, the
second is more inward, more empathic. The 1870 text describes
not how she looked but how she felt with words such as "weary"
and "pain."

This stylistic shift from a verbal pictorialism indicates a deeper
rejection of the entire figural vision. For no longer does the art-
ist see a phenomenal world as separate and distinct from the
perceiving mind, as a world in which objects have an intrinsic

divine meaning that inevitably emerges from their pre-
cise representation.

With the elimination of the references to the transcendent in
the *Germ* version, domestic details no longer function as tran-
scendental signs, but only as stimuli for sensations. In lines that
remain unchanged in each version, the narrator tells how his
"tired mind . . . / Like a sharp strengthening wine . . .
drank / The stillness and the broken lights" (6;6). With the omis-
sion of stanzas seven and eight of the *Germ*, these lines are
immediately followed by the words "Twelve struck" (9;7). With
the reference to religious experience removed, the sounds of the
bell become merely sounds, mere sensations rather than figures
of God's providence bringing a new day and a new birth. Simi-
larly, with the rejection of *Germ* stanzas 12 and 13 describing the
mother's prayer as a truly religious act in which, as if impelled by
a power outside himself, he must join, the sensibility of the
narrator becomes purely aesthetic, drinking in the sound of
silence, acutely aware of the distinct sounds made by his
mother's needles and her settling gown (10;8). If in the Brother-
hood text the intensity of sense perception strengthens the
ability to discover divine meaning within the events of every-
day life, with the abandonment of figural purpose in the 1870
text, the same intense perception of the physical world only
subverts whatever sense of the sacred is called up by icono-
graphic associations.

During his Brotherhood period, Rossetti made one other
major effort to sacramentalize events of contemporary life. *Found*
(no. 64) follows one of the chief Brotherhood aims—to endow
the "low" subjects of genre painting with "high" moral serious-
ness through figural treatment. In its first sketch in 1853 (no.
64B), the subject is conceived as typical, as the manifestation in
present time of a transcendent moral principle prefigured in the
Old Testament narrative. To emphasize this reading, Rossetti
includes in the original design a gloss from the Old Testament, "I
remember thee—the kindness of thy youth, the love of thy
betrothal" (Jer. 2:2). The completed portions of the work are
done with a scientific realism, the wall from a specific specimen
at Chiswick and the calf with great difficulty from an actual
netted calf. Characteristically, these natural facts are set into
configurations that point to the event as typifying a more gen-
eral principle, here the hope of divine redemption as still pres-
ent in contemporary life. A modern critic can hardly improve
on the figural reading provided by Rossetti's Brotherhood col-

PLATE 17. D. G. Rossetti, *Found* (no. 64). Delaware Art Museum, Samuel and Mary R. Bancroft Collection.

league, Stephens: "The girl crouches against the wall of a churchyard—'where the wicked cease from troubling, and the weary are at rest'; that the brightening dawn symbolizes, as it may be, peace (with forgiveness) on earth, or in Heaven, after sorrow; while the calf trammelled in the net, and, helpless, carried in the cart to his death, points to the past and present life of the girl" (Stephens, *DGR*, 38–39).

The history of the work amply illustrates how ambivalent Rossetti was, even during his Brotherhood period, to this fusion of moralism and naturalism. As with "My Sister's Sleep," his revisions subvert the original figural plan. The gravestone in the earliest sketch (no. 64B) has legible scriptural tags enforcing the typological conception: "There is joy . . . the Angels in he . . . one sinner that. . . ." In the next sketch, done in 1855 (no. 64A), the writing on the gravestone has become merely decorative lines; and in the final painting, the graveyard has entirely disappeared. But Stephens's comment that Rossetti was "overscornful of didactic art, and thoroughly indisposed towards attempts to ameliorate anybody's condition by means of pictures" (Stephens, *DGR*, 37) needs qualification. Rossetti's inability to finish the work certainly suggests that as he drew away from the Brotherhood, he found this modern moral subject uncongenial. But it must be emphasized that not only was the work conceived in 1853 in accord with the Brotherhood program but that he overtly endorsed the Brotherhood aim of transforming genre painting into high art. In 1855, he wrote to Hunt in Palestine to note that the conception for *Found* was not borrowed from *The Awakening Conscience,* exhibited in 1854. As he tells Hunt of the "most lovely motto from Jeremiah" that his sister Maria has found and the calf as a "beautiful and suggestive part of the thing,"[12] the subdued, friendly tone and the implicit admiration of *The Awakening Conscience,* speak of a shared purpose in representing the situation of the Victorian fallen woman with sympathy and dignity through figural treatment.

The most successful product of the Brotherhood desire to create a new illustrated Bible of contemporary life is Hunt's *Hireling Shepherd* (R.A., 1852), a work consistent in its figural scheme, orthodox in its moral meaning, and democratic in its implications.

Although exhibited with a quotation from Edgar's song in *King Lear,*

> Sleepest or wakest though, jolly shepherd?
> Thy sheep be in the corn;

PLATE 18. Holman Hunt, *The Hireling Shepherd*. Reproduced by permission of the City of Manchester Art Galleries.

> And for one blast of thy minikin mouth,
> Thy sheep shall take no harm.

the work is only tangentially a literary painting. Edgar's song calls up in Hunt a personal response, a vision of moral conflict that exists in the life of all men. In an important letter of 1897 to J. Ernest Pythian aimed at "unravelling the symbolism of the picture" on its acquisition by the Manchester City Art Gallery, Hunt says: "Shakespeares song represents a Shepherd who is neglecting his real duty of guarding the sheep: instead of using his voice in truthfully performing his duty, he is using his 'minikin mouth' in some idle way. He was a type thus of other muddle headed pastors who instead of performing their services to their flock, which is in constant peril—discuss vain questions of no value to any human soul."[13] Hunt's use of the word "type" indicates his overtly sacramental aim, his Carlylean purpose of showing the supernatural principles prefigured in Scripture being manifested in contemporary life. The necessity of such a reading is emphasized by the title with its readily available allusion to Christ's parable of the Hireling Shepherd (John, 10:11–14).[14]

It is for this ethically serious treatment of a genre subject that Hunt is praised by his Brotherhood colleagues. Writing in 1852, William Michael Rossetti says that the "moral is expressed in the words 'The Hireling Shepherd.' . . . It is evident from Mr. Hunt's title that the seemingly unimportant incident of the old song has been treated not merely as a casual episode of shepherd life, but with a view to its moral suggestiveness" (*Fine Art*, 235). Stephens describes the work in the morally resonant language of Victorian art criticism: "It represents a shepherd who has neglected his charge, to make love to a girl of his class. . . . Thus, while their guardian busied himself with idle fears, his duty was neglected, and the flock got into real trouble" (Stephens, *Hunt*, 20–21).

For Hunt, as for Carlyle, moral purpose demands faithful observation of life on the lowest economic levels of contemporary England. As Hunt states in his 1897 letter, his "first object as an artist was to paint not dresden china bergers, but a real Shepherd, and a real Shepherdess." But the "genuine thought" of the work (Stephens, *Hunt*, 19) lies in its success in ordering this accurately represented scene into parallels with traditional iconography so as to communicate a sense of sacred meaning. The shepherd disregarding his flock, who have become "blown" by eating the grain, has the evident suggestion of neglected duty. Similarly, Hunt's *Strayed Sheep* of the same year, although

[89]

lacking in human incident, takes on the quality of parable through its allusion to the same iconographic tradition. In *The Hireling Shepherd,* the lush setting, the isolated couple, and the half-eaten apple on the girl's lap provide a clear reference to Adam and Eve, thus transforming the agricultural laborers into types of sexual temptation. So too, the death's-head moth and the "miry places" (Stephens, *Hunt,* 20) at the girl's feet are natural symbols of the judgment of God.

In the treatment of landscape itself, the work exemplifies the Ruskinian idea of Truth in which the faithful representation of the visible world leads to sacramental significance. Indeed, Hunt notes in the letter to Pythian that his purpose was not only to see the moral significance of pastoral life anew, but, in the manner of the artists before Raphael, as well as in the manner of the experimental scientist, to confront the natural world directly, without preconceived theories. He says that his "object as an artist was to paint . . . a landscape in full sunlight, with all the color of luscious summer, without the faintest fear of the precedents of any landscape painters who had rendered Nature before." Not only through the glowing, colored shadows or the reflection of light on water but through the luminous quality achieved by the Brotherhood method of white underpainting, the outdoor scene is infused by light. But this concern for the scientifically accurate rendering of optical effects is not merely mimetic. For Hunt, as for Turner, the sun is God; the atmospheric effects show God's light permeating the world and offering to this couple, as to the kept woman in *The Awakening Conscience,* the hope of redemption from sexual sin.

This figural treatment of rural landscape and rustic characters marks a sharp break with much mid-century artistic practice. By giving a high religious significance to a low subject treated with the particularization associated with genre painting, Hunt violates the Academic decorum of linking noble themes only with high subjects treated with Raphaelite idealization. This moral elevation of genre painting is as much an expression of Hunt's democratic ideals in the years immediately following 1848 as his own more overtly political *Rienzi.* The serious treatment of genre material transcends the demeaning vision of much Academic genre painting that sees the lower classes as fit objects for charity by their betters or as an inferior species participating in quaint customs for the amusement of middle-class observers.[15] Like George Eliot in *Adam Bede,* who also links the detailed observation of Dutch genre painting with moral seriousness (chap. 17), Hunt shows rural workers as engaged in the patterns of tempta-

tion and salvation that have engaged people of all classes through historical time. For Hunt, then, as for Carlyle, the figural mode provides a means of resolving one of the great dilemmas confronting mid-Victorian art and literature—how to ennoble and give significance to contemporary life.[16]

1. "Some remarks on the Subject of the picture entitled 'A Converted British Family sheltering a Christian Missionary from the persecution of the Druids,'" MS for Thomas Combe (1851), Ashmolean Museum. The following quotations are from this MS.

2. Quoted in G. H. Fleming, *Rossetti and the Pre-Raphaelite Brotherhood* (London: Hart-Davis, 1967), p. 117.

3. Bulwer's *Rienzi* initiated a vogue for archeologically exact historical fiction that lasted through the 1840s. See James C. Simmons, "The Novelist as Historian: An Unexplored Tract of Victorian Historiography," *Victorian Studies* 14 (1971): 293–305.

4. *Rienzi* (London: Routledge, 1854), p. vii.

5. *Rienzi*, p. viii.

6. For discussion of social awareness in Brotherhood work see Alastair Grieve, "A Notice on Illustrations to Charles Kingsley's 'The Saint's Tragedy' by Three Pre-Raphaelite Artists," *Burlington Magazine* 111 (1969): 290–93.

7. John Guille Millais, *Life and Letters*, 1:135.

8. No. 1332 (7 May 1853), p. 567.

9. Because most critics have examined only the 1870 text rather than the *Germ* version, they have incorrectly seen the poem as exemplifying the problematical nature of Rossetti's religious belief as well as an apparent opposition between his use of detailed realism and religious symbolism. See Harold L. Weatherby, "Problems of Form and Content in the Poetry of Dante Gabriel Rossetti," *Victorian Poetry* 2 (1964): 11–19; Jerome J. McGann, "Rossetti's Significant Details," *Victorian Poetry* 7 (1969): 41–54; James G. Nelson, "Aesthetic Experience and Rossetti's 'My Sister's Sleep,' " *Victorian Poetry* 7 (1969): 154–58.

10. The first number in parentheses gives the stanza in the *Germ* text, the second the stanza in the 1870 text.

11. See Bentley, "The Belle Assemblée Version of 'My Sister's Sleep,'" p. 328.

12. Quoted in Surtees, 1:28.

13. MS letter of 21 January 1897 to J. Ernest Pythian, Manchester City Art Gallery. Quoted here with the permission of the City of Manchester Art Galleries.

14. The discussion of this painting follows some of the same lines as the fine article by John Duncan Macmillan, "Holman Hunt's *Hireling Shepherd*: Some Reflections on a Victorian Pastoral," *Art Bulletin*, June 1972, pp. 187–97.

15. As examples, see William Collins, *Rustic Civility* (1833) or Thomas Webster, *A Village Choir* (1847), both in the Victoria and Albert Museum and conveniently reproduced in Raymond Lister, *Victorian Narrative Paintings* (New York: Clarkson Potter, 1966).

16. See Humphrey House, "Pre-Raphaelite Poetry," in *All in Due Time* (London: Hart-Davis, 1955).

LITERARY PAINTING

The most striking quality of Brotherhood literary painting is its representation of wholly fictive scenes as historical events occurring at a specific time and place in the past. In formal terms, this method transforms literary events into types, manifestations of transcendent ethical principles within historical time. But, in keeping with the Brotherhood aesthetic, the underlying purpose of this mode is moralistic. Setting imagined events in the hard world of fact—the representation of Lorenzo and Isabella at a family meal or Claudio and Isabella in a prison cell—is intended to force the viewer to see the ethical conflicts that these scenes embody as experienced within the daily actuality of human life; any idealization or mimetic failure would attenuate this moral purpose by removing the event from that shared, tangible world in which moral choices must be made.

It is this Ruskinian drive toward moralized realism that the Brotherhood saw as setting their own literary painting apart from contemporary work in this enormously popular genre, from what Stephens dismisses as "the ever-repeated themes taken from the 'Vicar of Wakefield' and the like,—at best but second-hand ideas" (Stephens, *Hunt*, 10). Stephens's comment points to the Brotherhood impulse, so evident in the treatment of scriptural history, to break away from exhausted visual conventions so as to gain for their themes fresh intensity through novelty and surprise. Furthermore, the elimination of such popular subjects as *The Vicar of Wakefield* indicates the Brotherhood rejection of the sentimental mode, that arousal of feeling for its own sake they called "slosh," for the tough-minded visual representation of daily activity embodying severe ethical conflict. Furthermore, the Brotherhood felt literary paintings should demonstrate "thought," the careful arrangement of accurately presented fact so as to figure ethical principles. As Stephens states, "They determined these pictures should at least *mean* something; be no longer the false representations of sham sentiment, but express thought, feeling, or purpose of the painter's own mind, not a chromatic translation of a novelist or poet. Here lies the gist of Pre-Raffaelitism; this is what really distinguishes the movement" (Stephens, *Hunt*, 12–13).

But, as Stephens correctly observes, Brotherhood literary

paintings often provide less a "chromatic translation of a novelist or poet" than "purpose of the painter's own mind." The tendency of all Brotherhood work toward such expression of the "painter's own mind" becomes more pronounced in literary painting because private vision is less fully controlled by the subject matter. The fresh treatment of scriptural material can provide a publicly available reading because of the traditional typological meanings implicit in the subject. But in applying this same desire for originality to literary painting, the Brothers turn to new subjects, such as the poetry of Keats or Browning, for which there is no traditional contextual meaning, no interpretation shared by artist and audience. Since meaning is not generated by the subject, it must be created by the artist, often through a highly personal reading of the text.

Characteristically, it is Hunt who most consistently constructs his literary painting according to a figural scheme. Indeed, Hunt considered the moralized treatment of literary material as one of the founding ideas of the Brotherhood. In his 1846 conversation with Millais, he proposes the ethical reading of Keats's poem that underlies his *Flight of Madeline and Porphyro (Eve of St. Agnes)* (R.A., 1848): "The story in Keats's *Eve of St. Agnes* illustrates the sacredness of honest responsible love and the weakness of proud intemperance, and I may practise my new principles to some degree on that subject" (Hunt, 1:85). In the autobiography, this assertion of the revolutionary nature of such moralized illustration of Keats immediately follows his declaration of the importance of historicist treatment of the biblical story. The juxtaposition indicates Hunt's sense of a continuity between the figural treatment of imaginative literature and of Scripture. In each, the shock of historicist presentation evokes the presence of the divine within the temporal world.

The flight of Madeline and Porphyro during the drunkenness attending the revelry casts the Keatsian richness of tactile detail into moral types. In characteristic Brotherhood fashion, Hunt seeks to create the illusion of an observed historical event. The mistletoe was hung to get what Hunt calls "the approximate night effect," the bloodhounds painted from life and the models taken from the artist's circle so as to intensify the sense of participation (Hunt, 1:98). The composition represents a conflict between opposing moral principles. Madeline and Porphyro, the types of "honest responsible love," look back upon the world of "proud intemperance" from which they are about to escape. Associated with the lovers is another figure of love, the dogs whose "sagacious eye an inmate owns."

Opposed to the lovers are multiple types illustrating the

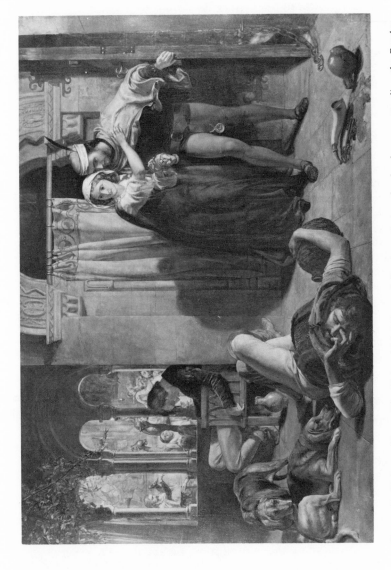

PLATE 19. Holman Hunt, *The flight of Madeline and Porphyro during the drunkenness attending the Revelry*. Reproduced by permission of the Guildhall Art Gallery, City of London.

"weakness of proud intemperance." In the foreground, the object of the stares of the fleeing couple, is "the Porter, in uneasy sprawl." The "huge empty flaggon by his side" is a detail from the text, but the objects in the lower right—the wine vessels, the unused horn, and the key—are additional elements invented by Hunt to figure the "weakness" of intemperance as opposed to the power of sacred love seen in the fallen chain and opened door. The sleeping page in a direct line with the fallen porter is invented by Hunt as another modulation of the theme. The addition of these moralized details indicates the degree to which Hunt's painting depends upon a very personal, very Puritanical reading of the text, the extent to which he has imposed his own high valuation of "responsible love" onto Keats's poem.

Form is moralized. The lines of the painting equate porter, page, and revelers. From the two drunken men who have neglected their domestic responsibility, the eye is led to the illuminated revelry of those whose intemperance has corrupted the entire household. There is no single principal light; illumination falls on lovers and revelers equally in order to emphasize the ethical contrast. The gaze of the lovers is not directed toward each other in a show of personal sentiment, but toward the fallen porter, the type of the moral corruption from which they are escaping. The unnatural size of the porter, his virtual giant-like stature, is partly due to difficulties with foreshortening by the young artist, but it is also indicative of how close such moralized literary painting can come to the allegorical mode.

The divergence of what Hunt called the "new principles" of the Brotherhood demonstrated in this painting from Academic practice becomes clear through comparison with a literary painting done by Hunt before the Brotherhood period, *Little Nell and her Grandfather* (1845). Here, the lack of hard-edge outline and the concern with atmospheric effects rather than the solidity of objects removes the event from the tangible world of common experience. There is no "thought," no effort to draw the facts of daily life into an ethical pattern. In *The flight of Madeline*, the lovers look not at each other, but at the porter, for the purpose of this painting is not to evoke the emotional quality of romantic love but to demonstrate the divine power of sacred love. In this earlier work, Nell and her grandfather gaze into each other's faces in a composition that stresses not moral principles but mutual love, the strength of personal feeling between two individuals.

In the year following Hunt's *Flight of Madeline*, Millais, with his ability to absorb and master styles, produced *Lorenzo and Isabella*

PLATE 20. Holman Hunt, *Little Nell and Her Grandfather*. Reproduced by permission of the Sheffield City Art Galleries.

PLATE 21. John E. Millais, *Lorenzo and Isabella*. The Walker Art Gallery, Liverpool.

(R.A., 1849), illustrating Keats's "Isabella; or, the Pot of Basil." Although the work appears to carry out Hunt's high aims for literary painting, it also turns figural methods toward a distinctly secular celebration of eroticism. Executed when Millais had become as "ardent an admirer of Keats" (Hunt, 1:103) as had Hunt and Rossetti, it was the first joint project of the group and was signed with the initials "PRB." With its flat picture plane, uniform illumination and lack of compositional focus, the work rejects the manner of the Royal Academy. In method, it is historicist. In an early sketch (no. 230), the Duomo of Florence appears through the arched window, much as the Ponte Vecchio appears through a window in Rossetti's Dantean illustrations, to set the event firmly in history. In the detailing, Millais is concerned with archeological exactness. He sketched the design for the rear wall from a Gothic revival pattern of the 1840s (no. 235) and the dress from a recently published book of historical costume (no. 237). Here, as in Brotherhood history painting, the conscious violation of Academic conventions of composition and lighting suggests the accidental quality of an observed event and the use of members of the circle as models enforces the sense of historicist participation.

In a narrow sense, the painting adapts typological methods by showing the present as prefiguring a future event known to the viewer from the narrative context. The pot of basil in the right background as well as the spilling of salt and cracking of a nut by the brother refer to the death of Lorenzo. Furthermore, in choosing a text to accompany the painting, Millais uses not only the lines describing the scene on canvas—"They could not sit at meals but felt how well / It soothed each to be the other by"—but those presenting the event prefigured by the painting, the murder of Lorenzo:

> each unconfines
> His bitter thoughts to other, well-nigh mad
> That he, the servant of their trade designs,
> Should in their sister's love be blithe and glad.

Working in his initial enthusiasm for the Brotherhood and still under the influence of Hunt, Millais felt a continuity between his figural treatment of literary and of scriptural subjects. In the same year that *Lorenzo and Isabella* was exhibited, he drew a design for a painting entitled "The Eve of the Deluge" (no. 257). This composition, which he showed to his colleagues, presents, like *Lorenzo and Isabella*, a domestic grouping around a table; his explication, in a letter to Combe of 1851, indicates that he in-

PLATE 22. John E. Millais, *The Eve of the Deluge*. Reproduced by courtesy of the Trustees of the British Museum.

tended each character to figure a different moral principle. The scene is set at a wedding-feast during the Deluge:

> The bride elated by her happiness, will be playfully showing her wedding-ring to a young girl. . . . A drunkard will be railing boisterously at another. . . . There will also be the glutton quietly indulging in his weakness, unheeding the sagacity of his grateful dog. . . . Then a woman (typical of worldly vanity) apparelled in sumptuous attire. . . . All deaf to the prophecy of the Deluge . . . all but one figure in their midst, who, upright with closed eyes, prays for mercy. . . . I hope by this great contrast to excite a reflection on the probable way in which sinners would meet the coming death.[1]

In the contemporaneous *Lorenzo and Isabella*, this same composition is applied to a literary rather than a scriptural subject. But since Keats's poem, unlike the subject of the Flood, provides no readily available context, moral and sacramental significance must be created by the artist's handling of the material. With its evident division into opposing groups, the painting can best be read, using the model of Hunt's own explication of his *Flight*, as figuring the conflict between malice and love. In the left-hand group embodying the varieties of malice, the clearest example of hatred is the brother in the foreground viciously cracking a nut while gazing at Lorenzo and Isabella. Behind him is a falcon tearing a bird's feather, one of the moralized details added from earlier sketches. The similarity between bird and man is emphasized by the formal equivalence of pose, each tilting forward with an echoing curve of the back, and conceptually in that each demonstrates his true nature through play, one in rending a feather, the other in breaking a nut. The brother is given a chair of ball-and-claw design so that even the legs of the chair seem to reach out to tear and rend. And yet, it is important to note that the bird and chair are not to be seen in the modern sense as representing the psyche of the brother, but rather bird and the man are each types, varied phenomenal manifestations of the principle of hatred.

The brother's elongated leg connects this group to the opposing elements embodying the different forms of what might be called noble love. The dog, as in Hunt's *Flight* the emblem of selfless love, shrinks from the brother's kick and, powerless, is yet protective, unlike the negligent, sleeping dog beneath the brother's chair. Isabella's chair is not clawed but carved, and bears the initials "PRB" as a kind of authorial commentary. The servant behind Isabella represents another type of love, the concern of the domestic servant. The lovers, oblivious to the varied expressions of care and malice around them, see

only themselves. The opened blood oranges on the plate not only prefigure the violence that will punish their love but rather daringly indicate the sexual basis of their attraction.

The passing of the oranges also follows the characteristic Brotherhood practice of evoking scriptural parallels. At this Last Supper, betrayed by those at the table, Lorenzo, dressed in a Christ-like dress reminiscent of *Rienzi,* passes the sacrament of the opened orange among those still faithful to him. There are thirteen people present; a passionflower blooms on the pillars behind the lovers' heads. Within a figural aesthetic, such iconographic associations suggest how the patterns of betrayal and martyrdom shown in the life of Christ continue through historical time. Yet, this application of religious symbolism to erotic content also indicates the connection of this work to the religion of Eros that flourishes in the art and literature of the later nineteenth century. The transformation of the sacrament to an erotic symbol, the punning use of the passionflower for its sexual rather than sacred meaning, the conception of Lorenzo as a martyr to love anticipate such works as the post-Brotherhood version of "The Blessed Damozel" in its use of Christian iconography to endow erotic life with significance.

In his own post-Brotherhood treatment of Keats's poem *Isabella and the Pot of Basil* (1868), Hunt, too, reverses the traditional meaning of Christian symbolism, here bringing out the decadent elements in the text. Isabella engages in a necrophilic worship of the flowering plant, which is set upon a prie-dieu covered with an elaborate altar cloth. Within the parodic conception of a religious sanctuary, the unmade bed serves as the antechamber and, as in the *Ecce Ancilla,* the lighted lamp indicates the presence of the Holy Spirit.

In the same year that *Lorenzo and Isabella* was exhibited, Millais began *The Woodman's Daughter* (R.A., 1851), another figural treatment of a contemporary poem. The painting is based on Patmore's "The Woodman's Daughter," a melodramatic narrative of the seduction of a young girl by the squire's son, her drowning of the illegitimate child and consequent insanity. In particular, the canvas illustrates the moment in childhood when, as described in the lines exhibited with the painting,

> He sometimes, in a sullen tone,
> Would offer fruits, and she
> Always received his gifts with an air
> So unreserved and free.

As in *Lorenzo and Isabella,* or even *The Carpenter's Shop,* the work is prefigurative in that the childhood scene foreshadows fu-

PLATE 23. Holman Hunt, *Isabella and the Pot of Basil*. Laing Art Gallery, Tyne and Wear County Council Museums Service.

PLATE 24. John E. Millais, *The Woodman's Daughter*. Reproduced by permission of the Guildhall Art Gallery, City of London.

ture suffering as well as figural in that the characters typify ethical principles. The red hair of the young squire as well as his preternaturally adult expression transform him into a type of the demon-child-lover and contrast to the innocence shown in the girl and the hardworking dutifulness embodied in the father. The offering of berries, a traditional emblem of sexual temptation also used in "Goblin Market," shows the boy as the embodiment of sexuality as well as pointing ahead to the future seduction. Even the landscape, painted *in situ*, is turned to moralistic purposes. The young plants in the foreground show the youthful present; the forest in the background the traditional dark wood in which the girl will be seduced and eventually drown her child.[2]

Millais's literary paintings indicate the transitional historical position of the Brotherhood artist, poised between sacramentalism and modernism. If *Lorenzo and Isabella* and *The Woodman's Daughter* look back to the figural mode of Carlyle and Ruskin, his *Mariana* (R.A., 1851) looks ahead to the *symboliste* manner, to the use of color and detail to evoke diffuse emotion. This *symboliste* mode spoke deeply to Millais's imagination connecting him with the similar impulses in Rossetti's Brotherhood work and with his poetic contemporaries, particularly Tennyson. Indeed, the distinction made by Arthur Henry Hallam in his 1831 essay on Tennyson between the poetry of "reflection" and of "sensation" applies equally well to Millais's Brotherhood productions.[3] If *Lorenzo and Isabella* is a work of "reflection," an example of visualized moral thought, his *Mariana* provides the visual equivalent of one of Tennyson's best poems of "sensation" in which, in Hallam's words, the mind trembles "into emotion at colors, and sounds, and movements."[4]

Just as for Tennyson the line from *Measure for Measure*, "Mariana in the moated grange," suggests neither the action of the play nor its ethical issues, but only a mood of claustrophobic dread, so, for Millais, Tennyson's poem suggests only an emotive state that can be evoked through tangible, visual forms. Within this *symboliste* conception, then, the Brotherhood style of minute particularity is turned to radically different purposes. Detail is employed not to typify but to evoke, not to figure a moral principle but to objectify an evanescent emotion. The extreme clarity of the style functions not to show the tangibility of the ordinary world but to mimic the hallucinatory mental state that is the subject of both poem and painting.[5] The mouse whose squeaking is heard with such intense clarity by Mariana as to

PLATE 25. John E. Millais, *Mariana*. From the Makins Collection.

become a shriek (ll. 63–64) is moved from behind the wainscot to scurry across the floor. The autumn leaves blown through the open window evoke the decay entering the interior space of the "dreamy house" (l. 61) that is her mind. Even the posture of Mariana in which the traditional erotic pose of outthrust hips is covered with heavy velvet suggests the suppression of sexual energy that, distorted, emerges as madness. Even William Michael Rossetti perceived the emotive rather than figural quality of the work: "Millais has expressed the weariness of mind by an outward action. . . . The house is haunted only by a thought" (*Fine Art*, 207–8).

Of this painting, Ruskin said, the "lady in blue is heartily tired of her painted window and idolatrous toilet table" (12:323). He is correct, but for the wrong reasons. Although the Brothers were aware of the Tractarian controversies of the moment,[6] the painting does not dramatize theological disputes. Here, the characteristic Brotherhood correspondence between domestic details and religious iconography functions not to reinforce but to subvert received Christian morality. Mariana is placed between a stained-glass representation of the Annunciation and a household altar, details not present in Tennyson's poem. Whereas in the *Germ* version of "My Sister's Sleep" such parallels to the Virgin praise the value of chastity, here the reference is ironic. Trapped by Christian sexual repressiveness, twisted by such constraints and unable to escape, she is forced toward madness.[7] Perhaps it is this powerful evocation of repressed female sexuality that made the work on its exhibition "a great favorite with women, one of whom said it was the best thing in the exhibition" (*PRBJ*, 91).

In his *St. Agnes Eve* of 1854 (no. 338), Millais also suggests the destructive effect of sexual repression through the ironic reversal of Christian symbols. In looking again to Tennyson, Millais fastens on the erotic ambiguities in the poet's depiction of a nun on Saint Agnes Eve praying for a vision of the Heavenly Bridegroom. Here, as in *Mariana*, a single female figure stands at an open window as if awaiting her lover. But within this cold winter landscape, the nun's virginity becomes identified with sterility; the twisted body of the crucified Christ above her personal altar is equated with the gnarled leafless tree in the garden. As in Hunt's *Flight of Madeline*, the half-opened gate suggests escape into sexual fulfillment. In its vision of a virginal young woman looking outward for a rescuer, this work, much like *The Order of Release*, suggests Millais's erotic feelings, especially for Effie Ruskin, to whom he gave the drawing. It appears that this personal meaning finally became evident even to Ruskin, for

when his marriage was breaking up, he told his wife that he now considered the drawing an unsuitable gift. [8]

Millais's best-known literary painting, *Ophelia* (R.A., 1852), continues his identification of virginity with madness. The painting again treats a single female figure, again focuses on a single moment of intense emotion. The remarkable detailing of the vegetation gives the work, like *Mariana,* a preternatural clarity that replicates the hallucinatory vividness of the world as seen by a deranged mind. And as in *Mariana,* the literary context functions not to provide the narrative line but to provide reasons for the disturbed emotions of the main character. Here, the painting appears to follow its source in illustrating Shakespeare's suggestion that Ophelia's madness arises from her inability to face the intense sexuality of the Danish court. The Queen describes Ophelia's final garland with sexual innuendo (4.7.168–70); Millais presents the English flowers overgrowing the pool and pushing to the front of the picture plane not as figures of the redemptive beauty of God's Creation but as signs of the fertile energy of the natural world. Within Millais's religion of Eros, Ophelia, like Lorenzo, becomes a martyr to unfulfilled love; her upraised hands, like the hand of the young Jesus in *The Carpenter's Shop* (plate 5), appear ready to receive the stigmata.

The divergence of *Ophelia,* and of *Mariana,* from the Brotherhood goal of moralized literary painting appears sharply when these works are contrasted to Hunt's treatment of a scene from Shakespeare, his *Claudio and Isabella* (R.A., 1853), based upon the prison scene in *Measure for Measure.* Neglecting Shakespeare's concern with the problematic nature of a choice between a man's life and a woman's virtue, Hunt turns the scene into a work that, in William Michael Rossetti's words, "shows forth the opposition between moral elevation and moral cowardice" (*Fine Art,* 236). Here, Brotherhood detailing presents Claudio's emotions, particularly his fear of death described in the quotation in the catalogue:

> *Claud.*
> Ay, but to die, and go we know not where;
> 'Tis too horrible!
> The weariest and most loathed worldly life,
> That age, ache, penury, and imprisonment
> Can lay on nature, is a paradise
> To what we fear of death.
> *Measure for Measure,* act iii, scene I

But Hunt's representation of the inner life carries with it moral judgment. As William Michael notes, "The impulse which di-

PLATE 26. John E. Millais, *St. Agnes Eve*.

PLATE 27. John E. Millais, *Ophelia*. The Tate Gallery, London.

PLATE 28. Holman Hunt, *Claudio and Isabella*. The Tate Gallery, London.

rects Claudio's unconscious hand to the manacled limb expresses as fully and quietly as we conceive it, the dread of death and the ignoble hope" (*Fine Art*, 236). Even the "Claudio/ Juliet" scratched on the wall of the condemned cell links the obsessive quality of his love with his failure to repent.

From original conception to completed canvas, Hunt worked carefully to eliminate evocative sentimental elements in order to present a scene figuring this clear moral distinction. In the first sketch (1850, no. 112), Isabella clutches her brother in a gesture of deep feeling. In the completed canvas, she is restrained in posture and separated from her brother to become a type of "moral elevation" contrasted, through this characteristic Brotherhood composition, to the "moral cowardice" figured in her brother. The only connection between the two are her overly large hands that, appearing virtually detached from her body, form a symbol of redemptive prayer on his chest.

As the work developed, Hunt's use of light, like his composition, became increasingly moralized. Following historicist principles, Hunt gained permission to draw from a prison cell in Lambeth Palace; he tells of hanging the lute in the "little window recess to get the true light upon it" (Hunt, 1:215). It is this "true light," in both the visual and moral sense of the term, that is the center of the work. In the 1850 sketch, one light floods the interior of the cell and another illuminates Claudio's face. In the final painting, both the prison cell and Claudio's face are cast into darkness while Isabella's face is partially illuminated by the brilliant sunshine that fills the out-of-doors. The sunlight beyond the cell irradiates a naturalistically treated landscape that, like Isabella's prayerful hands, figures the answer to Claudio's words, quoted in the catalogue, expressing his fear of death. The apple trees in bloom suggest the promise of resurrection and the steeple in the far background the revelation of immortality through the church. In Hunt's sacramental vision, the sunlight itself manifests the presence of God. As Stephens notes in moralized, Ruskinian language, Claudio has "turned his back upon the light" (Stephens, *Hunt*, 22). In the darkened cell that is the image of his own mind, Claudio not only looks away from his sister, who is illuminated by this sunshine, but also spurns the promise of redemption figured by the light that is God.[9]

Hunt's allegiance to figuralism continued beyond the Brotherhood period. The bright sunlight that figures the promise of immortal life to Claudio offers the same promise to the fallen woman in *The Awakening Conscience* (R.A., 1854). For

Millais, however, the authentic power as *symboliste* artist that appears in his Brotherhood literary painting continues into the later 1850s in a series of enigmatic paintings—*Autumn Leaves* (R.A., 1856), *A Dream of the Past; Sir Isumbras at the Ford* (R.A., 1857), *The Vale of Rest* (R.A., 1858), *Apple Blossoms* (R.A., 1859)—that point inward to the flux of emotion.

Of these, the most successful is *Autumn Leaves*. Begun shortly after Millais had completed his illustrations for the Moxon Tennyson, *Autumn Leaves* fully realizes the *symboliste* impulse evident in his Brotherhood illustration of Tennyson. But whereas Millais's *Mariana*, as well as Tennyson's poem, still refer to action within the literary source to account for the emotions of Mariana, *Autumn Leaves* indicates a conscious desire by the artist to eliminate narrative elements entirely from his work. His wife notes in her diary that Millais "wished to paint a picture full of beauty and without subject."[10]

Contemporary critics recognized the painting as repudiating the figural methods of the Brotherhood and yet accepted it as working within another well-defined mode, describing this rejection of narrative line and moral content for emotional suggestiveness as following the manner of Giorgione. William Michael Rossetti finds in the painting the same quality of complex, enigmatic feeling brought into stasis that his brother had praised in his sonnet on "A Venetian Pastoral, by Giorgione; in the Louvre" printed in *The Germ* and that Pater defines as the distinctive achievement of the School of Giorgione in *The Renaissance*. He says, "It is a work entirely of sentiment and effect; the evident object being, as in some pictures of the Venetians and eminently of Giorgione, to convey an emotion at once intense and undefined. Story there is none" (*Fine Art*, 217). Ruskin, too, evokes Giorgione in describing Millais's use of mimetic accuracy for emotive purposes. In *Academy Notes*, he says that the work is "by much the most poetical work the artist has yet conceived; and, also, as far as I know, the first instance of a perfectly painted twilight. It is easy, as it is common, to give obscurity to twilight, but to give the flow within the darkness is another matter; and though Giorgione might have come nearer the glow, he never gave the valley mist" (14:66–67).

The Giorgionesque quality of mystery, the suggestion of meanings that elude definitive reading, emerges from disjunctions within the painting itself. There is a disquieting stylistic break between Brotherhood scientific detailing and Giorgionesque colorism, between the leaves in the foreground rendered with such botanical particularity and hard-edge detailing that

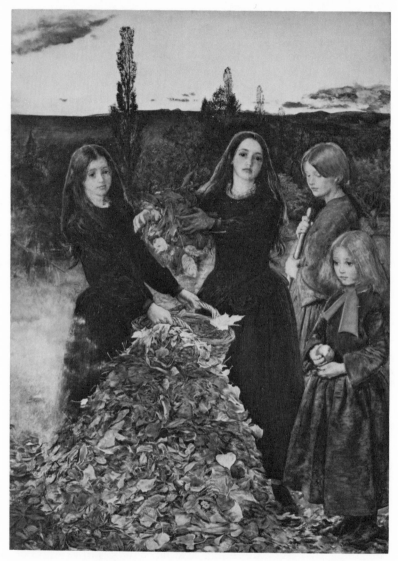

PLATE 29. John E. Millais, *Autumn Leaves*. Reproduced by permission of the City of Manchester Art Galleries.

each species is identifiable and the coloristic treatment of the girls' hair and dress, as well as of the landscape and atmosphere of the background. The twilight sky is a wash of pale yellow into which the line of poplars disappears. The sharply defined, tangible world of fact seems to dissolve into mist, or into dream. Then, too, there is a marked disparity between the Victorian viewer's expectation of a symbolic genre scene in the manner of F. M. Brown's *Work* or *The Hireling Shepherd* and the enigmatic quality of the depicted action. Inexplicably, the girls are detached from their task of gathering and burning the leaves. Each stands isolated, caught up in her own inner life, a solitary individual locked in the Paterian prisonhouse of the mind. Each is suspended in the somnambulistic trance so characteristic of women in the work of the later Rossetti and of Edward Burne-Jones.

Although landscape and event carry strong associations—the burning leaves of autumn and the glow of twilight suggest old age and death contrasted to the youthfulness and innocence of the girls—the force of the work is not directed toward the figuring of human mortality through natural fact and daily incident but rather toward the evocation of the evanescent feelings created by such a scene. The stylistic softening of the physical world and the inwardness of the actors suggest that the subject is not the manifestation of the divine within the phenomenal but the emotive response of the individual sensibility to external event. Millais's comment quoted by Hunt suggests that his conception of the work was *symboliste* rather than figural: "Is there any sensation more delicious than that awakened by the odour of burning leaves? To me nothing brings back sweeter memories of the days that are gone; it is the incense offered by departing summer to the sky; and it brings one a happy conviction that time puts a peaceful seal on all that is gone" (Hunt, 1:286). For Millais, then, the subject of the painting is not the transcendent but the favorite theme of the *symboliste* artist, memory, the complex and "delicious" mental "sensation" stimulated or "awakened" by incidents in daily life.

For Rossetti, as for Hunt and Millais, literary subjects offered a freedom to express personal imaginative impulses. If during his Brotherhood period Rossetti could work communally on moralized treatments of literature, he also shared with Millais an occupation with the claustrophobic repression of feeling that leads to madness. Although he sought to give his fictive subjects historical settings, there appears in these Brotherhood works the

[115]

tendency toward dream vision that culminates in his medieval fantasies of the 1860s. And if his illustrations of the *Vita Nuova* at first follow a figural program that points toward the transcendent, by the end of his Brotherhood association, the incidents from Dante have been transformed into representations of purely personal feelings.

Prior to the Brotherhood, Rossetti had experimented with literary illustration, selecting subjects from Poe, from German fairy tales, and from *Faust*. In the early days of the Brotherhood, he continued to illustrate *Faust* (nos. 34, 34A, 35, 35A, 36); but a comparison of his *Faust: Gretchen and Mephistopheles in the Church* (no. 34) of 1848 with his drawings of two years earlier, *Mephistopheles outside Gretchen's Cell* (no. 17) and *Faust with Skeletal Death* (no. 18) indicates his rapid assimilation of Brotherhood ideas. The pre-Brotherhood works draw upon the English caricature tradition. Mephistopheles outside the cell is a grotesque, dressed in a highly theatrical costume. The scene of Faust threatened by death is equally exaggerated in the swirl of Mephistopheles' cape and the lascivious poses of the female figures. The mode is non-naturalistic and ahistorical; the feeling is openly sexual. *Gretchen and Mephistopheles in the Church* (no. 34), done by Rossetti as a member of the Cyclographic Society, the immediate forerunner of the Brotherhood, is, in contrast, a tightly controlled moral statement conceived within a naturalistic scheme. As in *Lorenzo and Isabella*, the drama of sexuality takes place against the backdrop of an oblivious common humanity sketched with a high degree of particularization. Against these upright forms, the curve of Gretchen's body becomes an expression of moral agony. In the "Criticism Sheet" circulated within the group in July 1848, Hunt was quick to praise this typifying of sexual guilt: "Margaret enduring the taunting of the evil spirit who is pressing her weight of sin into her crouching and repenting self" (*PRBJ*, 110). Yet, for all the orthodox moralism, Rossetti, even in this early Brotherhood work, cannot wholly contain the supernatural within the bounds of the natural. The devil clearly contradicts the form of what is virtually a genre scene, and Millais, in his Criticism Sheet, criticizes his colleague for employing this exhausted visual convention: "The Devil is in my opinion a mistake; his head wants drawing and the horns through the cowl are common-place and therefore objectionable" (*PRBJ*, 110). The flaming sword in the foreground bearing the motto "Dies Irae," so similar to the crossed palm and briar in the *Girlhood* of the following year, also

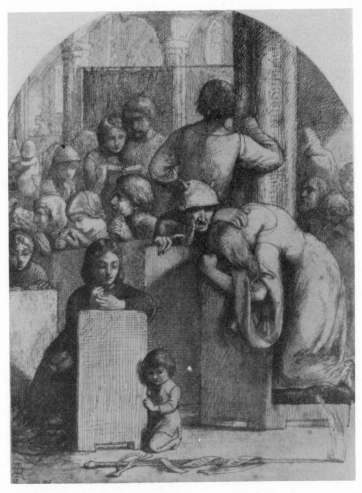

PLATE 30. D. G. Rossetti, *Faust: Gretchen and Mephistopheles in the Church* (no. 34).
Private collection. Photo A. C. Cooper.

violates naturalism, although Millais felt this detail justified by its moral purposes: "The flaming sword well introduced and highly emblematical of the subject" (*PRBJ*, 110).

Rossetti soon turned from *Faust* with its orthodox religious associations to the work of the then relatively unknown poet, Robert Browning. The "prodigious influence" of Browning within the group is attested by th?ir delight in hearing Rossetti read the poet's work aloud (Stephens, *DGR*, 26–27) and the inclusion of Browning as a "two-star" Immortal in the list compiled by Rossetti and Hunt in 1848 (Hunt, 1:159). Although many of Browning's explicit statements about art, particularly the Ruskinian assertion of the religious value of intense sense perception in "Fra Lippo Lippi" (ll. 282–96, 313–15), draw upon the same sacramental theory that informs Brotherhood work, the young Rossetti's attraction to the poet derives more from their shared occupation with the intensity of the moment and with hidden impulses that are close to madness. This congeniality of imagination is evident in Rossetti's first water color, the illustration of Browning's "The Laboratory" (1849, no. 41).[11] Here, Rossetti does not seek to typify moral principles, but to evoke the psychological atmosphere of the poem. The manic intensity of the speaker's hatred is conveyed through the focusing of the composition on the "delicate droplet" (l. 43) of poison as well as through the chiaroscuro illumination of her face and theatrically, perhaps too theatrically, clenched fist. Even the sense of compression created by the curved top of the frame points to the feeling of pent-up aggression. The work follows Brotherhood practice in the historical treatment of literature, but the effect of historicism in this case is to weaken moralistic purpose. Here, setting the fictive event in historical time serves the same function as it does in Browning; placing the event in the court circles of the Ancien Régime relativizes moral judgment by seeing murder as following the mores of a vanished society.[12] In its form, too, the painting can be seen as the visual equivalent of the poem, for within the tightly enclosed space of the canvas, as in a dramatic monologue, there is no alternative presented to the homicidal madness of the protagonist; there is only the passion itself.

Browning also provides the subject for Rossetti's one painting done from a contemporary literary source, "*'Hist!' Said Kate the Queen*" (1851, no. 49). This oil painting illustrates lines from one of Pippa's songs in "Pippa Passes":

> "Hist!"—said Kate the Queen;
> But "Oh!"—cried the maiden, binding her tresses,

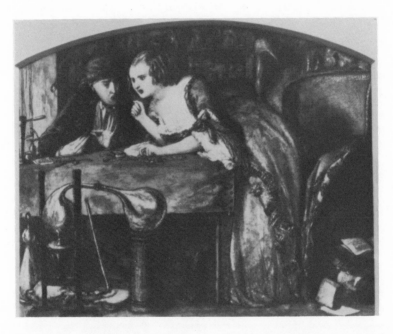

PLATE 31. D. G. Rossetti, *The Laboratory* (no. 41). Reproduced by permission of the Birmingham Museums and Art Gallery.

PLATE 32. D. G. Rossetti, "'Hist!' Said Kate the Queen" (no. 49). Reproduced by courtesy of the Provost and Fellows of Eton and Chatto and Windus Ltd.

" 'Tis only a page that carols unseen,
Crumbling your hounds their messes!"

(2. 258–61)

Although "Pippa Passes" is composed as a series of moral contrasts between Pippa and those who overhear her songs, Rossetti ignores the figural possibilities of his source as well as its contemporary setting. Instead, the relation of painting to poem is closer to that between Tennyson's "Mariana" and *Measure for Measure* or Browning's own "Childe Roland" and *King Lear*. For the lines from Browning touch off an entirely personal vision in the painter's mind, and the canvas illustrates this private world rather than the action of the poem. The canvas presents a dream-vision of a queen living in an Asolo of the imagination. As Rossetti moves from temporal to mental reality, he leaves behind scientific Brotherhood style. The hard-edge outlines dissolve, and the picture plane flattens. The maidens in the middle distance are arranged in serial patterns rather than with documentary randomness. In its decorative quality, the work points ahead to his treatment of medieval material in the 1860s.

In the same letter of November 1848 in which he outlines his historicist aims for *The Girlhood*, Rossetti mentions the *Vita Nuova* as "a work offering admirable opportunities for pictorial illustration: a task which I am now resolved to attempt" (*Letters*, 1:49). At this early point in his Brotherhood career, Rossetti felt a continuity between the treatment of scriptural and Dantean subjects, for in each the artist translates into visual form historical yet clearly figural events described in a verbal narrative. To Rossetti in 1848, the events of the *Vita* appeared meaningful in their fusion of historicity and sacredness; Beatrice was still, in Auerbach's words, "an earthly person who really appeared to Dante" and, simultaneously, "an incarnation of divine truth."[13] As much as he identifies with the Florentine Dante, in his earliest illustrations of the *Vita* Rossetti employs a historicist style to bring out the intermingling of the sacred and the human in Dante's life.

The Salutation of Beatrice (no. 116A), a drawing of 1849–50, remains close to the medieval religious quality of its source. Like the paired *Girlhood* and *Ecce Ancilla*, this work uses the diptych form to represent the prefigurative nature of earthly events. The two panels—the left showing the meeting of Dante and Beatrice in Florence, the right their meeting in Paradise—are visually separated to show difference in historical time, yet joined within a single frame to show their simultaneity in God's time. The separate compartments are connected by an emblematic device

PLATE 33. D. G. Rossetti, Study for *The Salutation of Beatrice* (no. 116A). Courtesy of the Fogg Art Museum, Harvard University, Bequest —Grenville L. Winthrop.

that suggests the interpenetration of divine and human time. In the space between the panels, the child Love gazes at a sundial; above his head is the date of death of Beatrice, 9 June 1290. The date sets the event firmly within historical time, while the personification of Love, set outside the visual representation of history and observing the shadow of the sundial fall on the number 9, sets past and future within the timeless present of God's foreknowledge.

In the left panel, the salutation in Florence, the hard-edge, rather awkward treatment works to establish the historicity of the event. Dante's head and his costume are modeled after a contemporary portrait; the costumes of the women and of the page provide the illusion of archeological accuracy. The architectural detailing, particularly the fresco behind Dante and the trefoil railing, as well as the view of the Arno in the far background, a characteristic device in his Brotherhood illustrations of Dante, set the event firmly in a particular time and place. As in *The Girlhood,* these objects of daily life appear as types. The volume of Virgil that Dante carries prefigures his journey through the Inferno to Paradise. The clear visual parallels of Beatrice accompanied by two women suggests, without annulling the historicity of the meeting in Florence, how the second event is contained within the first.

From the beginning of his Brotherhood years, Rossetti worked on a favorite subject from the *Vita,* Dante drawing an angel on the first anniversary of the death of Beatrice. In his drawing of 1849 (no. 42), the signature "Dante G. Rossetti P. R. B." and the dedication "To his PRBrother John E. Millais" assert his intention of treating the subject according to Brotherhood principles. The hard-edge modeling, the awkward posture of the characters, particularly of the young boy at the right who appears to be scratching his leg, the detailing of surfaces, such as Dante's chair, and the Florentine street-scene visible through the window establish the work as, in Rossetti's own terms, "pictorial illustration," the representation of the domestic ambience of the actual historical event described in the text. The treatment remains firmly natural rather than supernatural, yet the household objects bear figural significance. The half-empty hourglass indicates this moment as a midpoint in Dante's life before being received into heaven by Beatrice. The statue at the left refers to Beatrice in showing Mary crowned as received into heaven, and the rose indicates the final attainment of heavenly joy. In suggesting such sacred meaning through a domestic scene, the drawing is continuous with such Brotherhood scriptural work as

PLATE 34. D. G. Rossetti, *The First Anniversary of the Death of Beatrice* (1849) (no. 42). Reproduced by permission of the Birmingham Museums and Art Gallery.

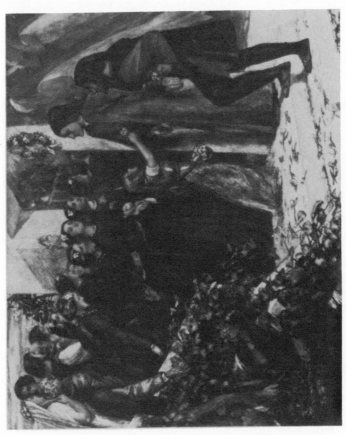

PLATE 35. D. G. Rossetti, *Beatrice Meeting Dante at a Marriage Feast, Denies him her Salutation.* Reproduced by permission of the Birmingham Museums and Art Gallery.

the Passover design (no. 78A) (plate 11), as well as with his treatment of contemporary domestic life in "My Sister's Sleep."

His *Beatrice Meeting Dante at a Marriage Feast, Denies him her Salutation* (1850, no. 50) continues this historical manner. The incident is represented as described in the *Vita*, including specific details mentioned in the text, such as the fresco on the wall of the house, the mocking women, the friend pulling Dante by the hand. No supernatural elements intrude. But this work, unlike *The First Anniversary* of 1849 (no. 42) (plate 34), does not add to Dante's account a set of symbolic visual parallels. Instead, it is almost pure "pictorial illustration," with the sacred meaning of the scene communicated primarily through the viewer's knowledge of the entire text.

Rossetti's treatment of Dantean material during the early Brotherhood period, then, tends toward history painting. *Giotto Painting the Portrait of Dante* (1852, no. 54) draws upon both the *Purgatory* and the *Vita* to invent a subject that is carefully conceived as being historically possible. He describes his scheme in a letter of 1853 to his Brotherhood colleague Thomas Woolner: "It illustrates a passage in the *Purgatory* . . . where Dante speaks of Cimabue, Giotto, the two Guidos (Guincelli and Cavalcante, the latter of whom I have made reading aloud the poems of the former who was then dead) and, by implication, of himself. For the introduction of Beatrice, who with the other women (their heads only being seen below the scaffolding) are making a procession through the church, I quote a passage from the *Vita Nuova*" (*Letters*, 1:123). In the watercolor, Giotto, with Cimabue looking over his shoulder, paints the portrait of Dante in the Bargello, while Guido Cavalcante reads from a volume of Guido Guincelli's poems and Beatrice passes beneath the scaffold in a procession of women. The scene "illustrates a passage in the *Purgatory*" in that this incident prefigures the future meeting of Dante in Purgatory (11. 94–99) with the painter Oderisi, who speaks of Giotto wresting fame from Cimabue in painting just as Guido Cavalcante does from Guido Guincelli in poetry. The "introduction of Beatrice," however, fits only tenuously into any prefigurative plan; rather, her inclusion points to the personal element in the work. Rossetti concludes his explanation by saying, "I have thus all the influence of Dante's youth—Art, Friendship and Love—with a real incident embodying them." Just as Rossetti notes that in canto 11 of the *Purgatory* Dante speaks "by implication, of himself," so in this watercolor Rossetti is expressing through his characteristic identification with Dante his own youthful desires for artistic fame, for "Friendship" within the

PLATE 36. D. G. Rossetti, *Giotto Painting the Portrait of Dante* (no. 54).

Brotherhood, and for sexual fulfillment. Still absorbed in the Brotherhood manner, however, Rossetti does not express qualities like "Love" and "Friendship" through allegorical personification, as he does in such post-Brotherhood works as the *Beata Beatrix* (1864, no. 168) (plate 39), but as figured through historical events, "with a real incident embodying them."

By the end of the Brotherhood period, the stylistic balance in Rossetti's treatment of Dante has begun to shift from the historical to the *symboliste*, from domestic realism to dream-vision. The 1853 reworking of *The First Anniversary of the Death of Beatrice* (no. 58), like the earlier version (plate 34), represents an event in the life of the historical Dante, but introduction of a visionary style moves the work beyond historical documentation. Stephens's reading of his Brotherhood colleague's work is useful in pointing to Rossetti's means of evoking the sacred:

> We see . . . a serene landscape, comprising a sunlit meadow, a shadowy wood, and, overhead, that brooding, softly-glowing firmament which, with Rossetti as with other poet-painters, attests the perfect peace of a Paradise beyond the grave. In this way, the artist took us from the busy Arno, past the dim, half-lighted room where Dante sojourned with his grief, and through the narrow pass of Death, whose purifying function is indicated by the basin and its appurtenances, until, remote but bright, the pleasuance of Eternity is discovered to be "beyond the veil," which is represented by the *portiere*. (Stephens, *DGR*, 35)

As in the 1849 version, the room itself is rendered with historical consistency. The daily life of Florence is visible through the windows, the figures wear medieval dress, and the room is filled with domestic objects, such as the hourglass, oval mirror, lilies, and painting of Virgin and Child, that demand figural reading. But the style attenuates the materiality of these objects. The use of watercolor softens the outlines and eliminates the close detailing shown, for example, in the earlier version's treatment of the surface of the chair. Without a hard, overall illumination, objects lose their tangibility, fade into sunlight or into shadow.

In the passage at the left, through the antechamber into the out-of-doors, the naturalistic style finally dissolves. The objects in the antechamber, which Stephens correctly sees as suggesting the "narrow pass of Death," retain some tenuous connection to historical probability, but in their treatment appear more as the iconic symbols of medieval art. Finally, the evocation of heaven through the "serene landscape" shows Rossetti less as the artist as scientist than as "poet-painter." The radiance at the top of the staircase and the blurred rather than leaf-by-leaf detailing of the

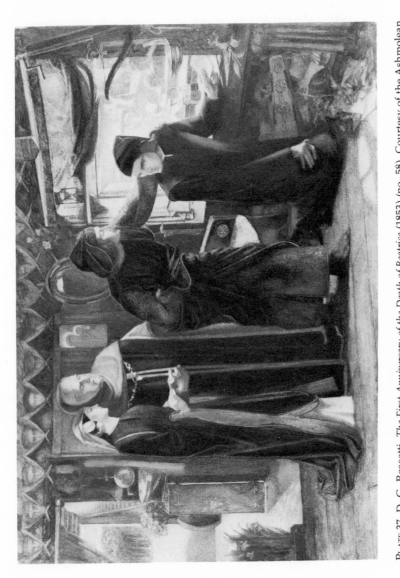

PLATE 37. D. G. Rossetti, *The First Anniversary of the Death of Beatrice* (1853) (no. 58). Courtesy of the Ashmolean Museum, Oxford.

trees suggest not domestic fact transformed into type but a wholly non-naturalistic vision.

The same occupation with finding tangible expression for the visionary also informs the Brotherhood version of Rossetti's best-known poem, "The Blessed Damozel."[14] As it appeared in the second issue of *The Germ*, the poem follows a Dantean, religiously orthodox mode.* Although it does not draw directly upon biblical typology as does "My Sister's Sleep," the *Germ* text manifests the same habit of mind, the "intimate intertexture of a spiritual sense with a material form" (*D&W*, 127) that William Michael saw as the defining quality of the Brotherhood, a quality that his own brother absorbed primarily from Dante. "Her bosom's pressure must have made / The bar she leaned on warm" (9) because, like Beatrice in Paradise, she retains a bodily form. And like Dante's Inferno and his Paradise, the Damozel's Heaven is seen as a sacred, yet tangible world:

> We two will lie i' the shadow of
> That living mystic tree
> Within whose secret growth the Dove
> Sometimes is felt to be,
> While every leaf that His plumes touch
> Saith His name audibly.

(14)

In this Brotherhood version, tree and Dove function traditionally, as material signs of the sacred. In particular, the Dove operates in the *Germ* text much as it does in *The Girlhood* or *The Carpenter's Shop,* as a physical manifestation of the Holy Spirit.

As in the case of "My Sister's Sleep," before including this Brotherhood poem in his 1870 volume Rossetti carefully removed the transcendental context that had given religious consistency to the original. The result is to liberate the erotic impulse present in the *Germ* version and thus create a work praising an earthly rather than a spiritualized Eros. In *The Germ,* stanza 8 pictures a scene of holy virgins engaging in the chaste pastimes of Heaven:

> Heard hardly, some of her new friends,
> Playing at holy games,
> Spake, gentle-mouthed, among themselves,
> Their virginal chaste names;
> And the souls, mounting up to God,
> Went by her like thin flames.

*The *Germ* text of "The Blessed Damozel" is reprinted in Appendix 2. Stanza numbers in parentheses refer to this *Germ* text.

By 1870, "holy games" had been altered to "loving games." By 1872, "virginal chaste names" had become "rapturous new names" and, finally, by 1881, "heart-remembered names." By 1876, the first two lines had been entirely recast to become explicitly erotic and the first four lines of the stanza then read:

> Around her, lovers, newly met
> 'Mid deathless love's acclaims,
> Spoke evermore among themselves
> Their rapturous new names.

It is this unequivocally erotic passage that occupies the center of Rossetti's first design for the background of the painting (1876, no. 244G). In this distinctly post-Brotherhood work, Rossetti's visual interest lies in the newly introduced erotic elements. The embracing couples are each represented in a circular form illustrating the restoration of separated halves to a perfect physical unity. The patterned rose-hedges in the foreground also suggest through design a unity achieved through physical intertwining. And the significance of this visual celebration of physical union is deeply personal; in the two couples embracing in the foreground, each woman has the head of Janey Morris.

In the *Germ* version, the Damozel is not Rossetti's later fleshly woman but the virginal, virtually presexual young woman that is the chief subject of his Brotherhood work, including *The Girlhood*, *Ecce Ancilla*, and "My Sister's Sleep." Described in this early text as having a "wise simple mind" (16), her request to Christ is that of a naïf, unaware in her holy simplicity of the spiritual riches that she might receive:

> There will I ask of Christ the Lord
> This much for him and me:—
> To have more blessing than on earth
> In nowise; but to be
> As then we were,—being as then
> At peace. Yea, verily.
>
> (22)

Within the Dantesque context of the original poem and with specific reference to the "virginal chaste" nature of the Damozel, the words "blessing" and "peace" here suggest a continuance in heaven of the asexual, saintly life lived on earth. By 1870, heaven is still imagined as the continuation of the life lived on earth, but Rossetti removes such religiously resonant terms as "blessing" and "peace" to transform these same lines into a vision of the endless enjoyment of sensuality:

> Only to live as once on earth
> With love,—only to be,

[131]

PLATE 38. D. G. Rossetti, Study for *The Blessed Damozel* (no. 244G). Courtesy of the Fogg Art Museum, Harvard University, Bequest —Grenville L. Winthrop.

As then awhile, for ever now
Together, I and he.

The force of the erotic feeling present in the *Germ* version is
evidenced most clearly in the way that, once the religious frame
is removed, language that remains essentially unchanged from
Brotherhood to post-Brotherhood versions takes on a clear sex-
ual meaning. To give two examples:

And I myself will teach to him—
I myself, lying so,—
The songs I sing here; which his mouth
Shall pause in, hushed and slow,
Finding some knowledge at each pause
And some new thing to know.

(15)

He shall fear, haply, and be dumb.
Then will I lay my cheek
To his, and tell about our love,
Not once abashed or weak:
And the dear Mother will approve
My pride, and let me speak.

(20)

In the Brotherhood version, "knowledge" and "new thing to
know" suggest a Neoplatonic spiritualization of earthly love; the
"love" in stanza 20 refers to the "virginal chaste" relationship
that meets the approval of the "dear Mother." With "love"
redefined as Eros, "knowledge at each pause, / Or some new
thing to know" (1870) suggests the continuous refinement of
sexual pleasure in each other. "Love" becomes fleshly eroticism
praised by a Mary whose unconventional symbolic meaning
draws upon Rossetti's newly created mythology.

If the values of the post-Brotherhood version are heterodox in
the elevation of fleshly love, the form is post-Christian in its
appropriateness to a world from which God has disappeared.
The tangible details in the poem no longer signify a transcendent
reality, but objectify diffuse emotion. The tree with its dove and
the murmuring leaves of stanza 14 now function as an evocative
landscape, a background as emotively appropriate to the lovers
as the entwined foliage surrounding the embracing couples in
the completed painting. Its force derives not from parallels with
religious iconography but from traditional associations of the
pastoral landscape with sexual delight. But because Rossetti,
unlike Blake or Yeats, could not construct a consistent mytholog-
ical system in which traditional symbols are revalued, the con-
ventional meanings derived from the original Christian context
continue to cling to the Dove, to Mary, and to heaven itself.

[133]

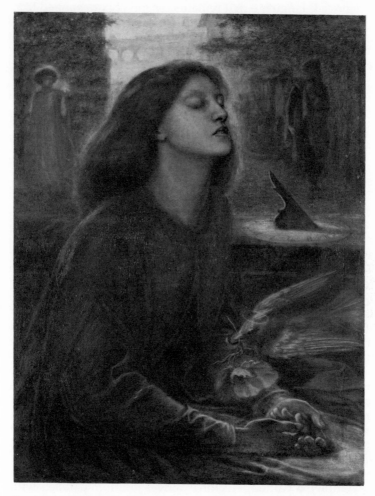

PLATE 39. D. G. Rossetti, *Beata Beatrix* (no. 168). The Tate Gallery, London.

Thus, the post-Brotherhood text suggests not what Rossetti intended—a new mythology celebrating the high value of Eros—but what he himself felt, an inner conflict between a longing for the Dantean spiritualization of love and an intense attraction to the pleasure of earthly eroticism.

The same liberation of a personal eroticism appears, too, in his post-Brotherhood visual treatment of Dante. The *Beata Beatrix* (no. 168), completed in 1870, is, for example, in many ways continuous with his earlier figural treatments of the *Vita*. The painting grew from an earlier sketch of his wife begun before her death for, in Rossetti's words of 1863, "a picture of Beatrice" (Surtees, 1:94). As late as 1871 Rossetti could justify the work in Brotherhood terms by noting that it "illustrates" the *Vita*, "embodying, symbolically, the death of Beatrice, as treated in that work"; it renders death "under the resemblance of a trance, in which Beatrice seated at the balcony over-looking the City is suddenly rapt from Earth to Heaven" (Surtees, 1:94). The Ponte Vecchio and Duomo in the far background set the scene in a historically real Florence. As in *The Salutation of Beatrice* (No. 116A) (plate 33) of 1849–50, the sundial with the shadow pointing to nine sets the event at a specific moment in historical time.

But for all the vestiges of Brotherhood figuralism, the completed painting follows new formal principles; there emerges here the allegorical, visionary manner barely contained in his earlier work. The bird bringing the poppy of death is given a halo; a personification of Love walks the streets of Florence. Instead of the random groupings that, as in *The First Anniversary of the Death of Beatrice* (1849) (plate 34), offer the illusion of an observed historical event, this composition, like the completed *Blessed Damozel* (no. 244), is highly symmetrical; Dante and Love appear on either side of Beatrice's head, with the light from the Arno forming a nimbus about her face. Similarly, the hard-edge manner gives way to colorism, and the uniform lighting so closely tied to Brotherhood historicism is replaced by chiaroscuro. This softened outline and diffused light had appeared in his Brotherhood Dantean work, but only to indicate a reality beyond the temporal, notably in *The First Anniversary* of 1853 (no. 58) (plate 37) where the out-of-doors representing the Paradise that Beatrice and Dante achieve is contrasted to the earthly room in which Dante writes. In the *Beata Beatrix*, however, the visionary style controls the entire painting as if, within Rossetti's post-Brotherhood imagination, the physical world had wholly disappeared.

[135]

In its rejection of a naturalistic style, then, the work breaks with Brotherhood ideas of literary illustration. The event is no longer represented as a historical fact, but employed as a symbol for the emotions of the artist, used to express the mixture of guilt and love that tormented Rossetti after the death of his wife. As in the revision of "The Blessed Damozel," elimination of the figural mode releases the eroticism implicit in earlier work. Although Rossetti, with overt fidelity to religious orthodoxy, describes his Beatrice as in "a trance . . . suddenly rapt from Earth to Heaven," he shows her as a woman, with lips parted, in a moment of sexual ecstacy.

1. J. G. Millais, *Life and Letters*, 1:103–4.

2. Discussion of this painting is indebted to research by Ms. Linda Granfield.

3. Arthur Henry Hallam, "On Some of the Characteristics of Modern Poetry," in Walter E. Houghton and G. Robert Stange, eds., *Victorian Poetry and Poetics* (Boston: Houghton Mifflin, 1968), p. 850.

4. Ibid.

5. This element in Pre-Raphaelite work is discussed by Christ, *The Finer Optic*, pp. 61–64, although she does not discuss Millais's *Mariana*.

6. Alastair Grieve, "The Pre-Raphaelite Brotherhood and the Anglican High Church," *Burlington Magazine* 111 (1969): 295, and Bentley, "Rossetti's 'Ave.'"

7. See the psychoanalytic reading of the painting by George MacBeth, "Subliminal Dreams," in *Narrative Art*, ed. Thomas B. Hess and John Ashberry (New York: Macmillan, 1970), pp. 29–33.

8. *Millais*, Walker Catalogue, p. 90.

9. The analysis of this painting is indebted to the research of Ms. Toby Gang.

10. *Millais*, Walker Catalogue, p. 41.

11. Stephens suggests that Rossetti was attracted to the poem as early as 1845 (Stephens, *DGR*, 26 n. 1).

12. For discussion of the problematic morality of this poem, see Robert Langbaum, *The Poetry of Experience* (New York: Norton, 1963), p. 86.

13. Auerbach, "Figura," pp. 73–74.

14. As in the case of "My Sister's Sleep," critics have failed to consider the relationships between the *Germ* text and later versions. See Weatherby, "Problems of Form and Content," and McGann, "Rossetti's Significant Details."

THE SCAPEGOAT

When Hunt took ship for the Holy Land in January of 1854, the Brotherhood had dissolved. As Christina Rossetti had written the previous year, "So rivers merge in the perpetual sea; / So luscious fruit must fall when overripe; / And so the consummated P.R.B." ("The P.R.B.").

And yet, with the irony that marks the history of the Brotherhood, it is Hunt's journey to Palestine of 1854 that must be seen as the consummation of the original aims of the group. As early as October 1850, the Brothers had discussed illustrating biblical events through paintings done *in situ*. At that time, Hunt had seriously considered "going to Jerusalem" to paint the subject of Ruth and Boaz "on the spot," and Rossetti, even against the "infidel" objections of his brother and Woolner, had wanted to join him (*PRBJ*, 73).

But by 1854, a joint expedition to Palestine by Rossetti and Hunt was unthinkable. Hunt alone was to carry on the work of the Brotherhood, his vision of sacramental realism shared neither by a Brotherhood of fellow artists nor by his audience. In 1856, Hunt returned from the Holy Land to exhibit in the Royal Academy show of that year the chief result of his trip, *The Scapegoat*. The perplexed, often hostile public response to the painting indicates some of the reasons why the figuralism practiced by Hunt and the Brotherhood, as well as by Carlyle and Ruskin, ultimately failed to establish a vital form of religious art in mid-nineteenth-century England.

The Scapegoat epitomizes Brotherhood figuralism. The subject is an actual scriptural event that has a clear typological meaning. The animal described in the Old Testament as sent into the wilderness bearing the sins of the Israelites (Lev. 16:22) prefigures the events of the New Testament, specifically the crucified Christ as Scapegoat bearing the sins of the world. The canvas, then, shows a historically possible, typologically significant event; the goat, expelled from the Temple, has wandered to the Dead Sea and flounders in the salt of the shore.

Hunt's methods also present an extreme case of the Brotherhood desire to achieve both scientific and historical accuracy. His zeal for Ruskinian truth drove him to Palestine in a quest that

PLATE 40. Holman Hunt, *The Scapegoat*. Courtesy of the Lady Lever Art Gallery, Port Sunlight, Merseyside, England.

stands on the narrow edge between heroism and obsession. To reach the Dead Sea, he traveled through lawless country armed only with a pistol and a sublime confidence in the sanctity of Englishmen. Once there he painted by the marshy shore, encountering heat and insects so uncomfortable that even Arab brigands withdrew before the sublime madness of this Englishman. This effort to paint *in situ* no matter what the cost extends that same desire to emulate the direct experimental observation of the scientist that had sent Ruskin to the Alps or the Brothers in search of the perfect brick wall. With the zeal of the Victorian geologist, Hunt painted from direct observation the geological truth of the strata of the hills and the salt formation of the shore. To achieve biological truth, Hunt painted the goat from the proper Palestinian species, but at a studio in Jerusalem. To achieve historical truth, he timed his visit to coincide with the period of the Day of Atonement so as to represent the particular quality of light at the time the goat was released from the Temple. The finished canvas, then, is as nearly as possible a representation of what an ancient Israelite might have seen had he been standing on the shores of the Dead Sea a short time after the Day of Atonement. Yet, this exacting scientific documentation is a means toward sacramental enlightenment—the representation of a possible scriptural event as historical truth should, in theory, provide the audience with fresh awareness of the figural quality of Scripture.

Hunt's heroic efforts were, however, appreciated by only a few associated with the Brotherhood circle. Ruskin praised Hunt's ardor, but his words, like Hunt's actions, now appear more droll than elevating:

> While the hills of the Crimea were white with tents of war, and the fiercest passions of the nations of Europe burned in high funeral flames over their innumerable dead, one peaceful English tent was pitched beside a shipless sea, and the whole strength of an English heart spent in painting a weary goat, dying upon its salt sand. . . . [It is a] scene of which it might seem most desirable to give a perfect idea to those who cannot see it for themselves; it is that also which fewest travellers are able to see; and which I suppose, no one but Mr. Hunt himself would ever have dreamed of making the subject of a close pictorial study. (14:62)

Ruskin judged the painting as valuable in its religious intentions, but as not realizing the full fusion of moral purpose and mimetic accuracy: "I acknowledge the good purposes of this picture, yet, inasmuch as there is no good hair painting, nor hoof painting in it, I hold it to be good only as an omen not as an achievement" (14:65). William Michael Rossetti, however,

praised the painting for presenting what Carlyle termed an
"intrinsic" symbol: "Its symbolism is of the highest kind of
all,—that where the symbol is a truth, accurate and consistent in
all its details, which the thing symbolized underlies and endows
with life" (*Fine Art,* 243). For William Michael Rossetti, as for
Ruskin and for Hunt, there is no doubt as to the sacramental
nature of the historical events described in Scripture, no doubt
that the figural quality could be communicated through art: "The
goat in the picture is a religious type in precisely the same
manner in which the goat wandering or perishing in the wilder-
ness was one" (*Fine Art,* 243).

The reviewers in the general periodicals were, however, gen-
erally hostile. They did not attack Hunt's mimetic skill; few had
the assurance of a Ruskin to judge the representation of a land-
scape they had never seen. But all agreed that if here was a
religious painting that must be valued for its symbolic signifi-
cance, the work failed in being far too difficult to read. Ruskin
characteristically blamed the audience for insufficient knowl-
edge of Scripture, but other critics blamed the painting itself for
not being more clearly self-explanatory in spite of the biblical
glosses on the frame. The *Times* said, "The distance is given well,
and the colour is very good, the mountains are most lovingly
painted; in the eye of the scapegoat, too, as it comes to drink the
waters of the Dead Sea, there is a profound feeling, but al-
together the scene is not impressive, and were it not for the title
annexed it would be rather difficult to divine the nature of the
subject."[1] Had there been an iconographic tradition of doleful
goats as a type of Christ, the meaning of the painting might have
been more available. But here, Hunt's continuing effort to re-
vitalize religious iconography leads to symbols that are highly
original, yet virtually indecipherable. Even the scientifically de-
tailed landscape is intended to have typical significance:

> The Sea is heaven's own blue like a diamond more lovely in a
> king's diadem than in the mines of the Indies but as it gushes up
> through the broken ice-like salt on the beach, it is black, full of
> asphalt ocum—and in the hand slimy, and smarting as a sting. No
> one can stand and say it is not accursed of God. If in all there are
> sensible *figures* of men's secret deeds and thoughts, then is this
> the horrible *figure* of Sin—a varnished deceit—earth's joys at
> hand but Hell gaping behind, a stealthy, terrible enemy for ever.[2]

But since these facts of landscape have no clear correspondence
with traditional iconography, this sacred purpose remains un-
available to most viewers. With the transcendental significance
hidden by Hunt's essentially private symbolism, the emotive

quality becomes dominant. The representation of a single living being trapped in a sterile wasteland represented in preternaturally vivid colors creates an almost hallucinatory sense of isolation and despair.

If Hunt's art rests on faith in a sacramental universe in which even a trapped goat can manifest a transcendental principle, the reviews make it clear that although the contemporary critics could understand Hunt's religious intentions, they no longer shared the metaphysical assumptions upon which his figural style depends. The remarkably perceptive review in the *Athenaeum* expresses the related philosophical and stylistic issues exactly: "The question is simply this,—here is a dying goat, which, as a mere goat, has no more interest for us than the sheep that furnished our yesterday's dinner—but it is a type of the Saviour, says Mr. Hunt, and quotes the Talmud. Here we join issue, for it is impossible to paint a goat, though its eyes were upturned with human passion, that could explain any allegory or hidden type."[3] To this reviewer, the correspondence between the Scapegoat and Christ, between the Palestinian goat and the spiritual principle of redemption, is not stylistically unclear; it is philosophically impossible.

The profound differences between Hunt and his periodical critics suggest that in the effort to revive religious art by using the contemporary methods of scientific and historicist accuracy, the true enemy was not Academic conventions but scientific materialism, the belief in a purely physical universe in which transcendental correspondences can have no real existence. The reviewers confront *The Scapegoat* as Peter Bell did the primrose. The *Athenaeum* concludes, "The goat is but a goat, and we have no right to consider it an allegorical animal." The *Art-Journal* agrees: "A Goat is here, that is all." For the *Art-Journal*, the main interest is scientific, but an interest no longer derived from a religious science that moves from detailed observation to knowledge of God. Instead, Hunt's landscape satisfies a geological curiosity occupied only with physical truth: "The only point in the picture that has any interest at all is the deposit of salt; this is interesting, if the representation be true: for ourselves, we have often read of this, but never have seen anything like a truthful picture of it."[4]

Although *The Scapegoat* "was the theme of eloquent eulogy on the part of more than one member of the Episcopal bench,"[5] it failed to achieve religious significance for most viewers because the transcendental belief upon which such meaning depends had become as exhausted as the traditional symbolic language of

art that Hunt and the Brotherhood had hoped to revitalize. If Hunt's intentions were traditional in wishing to fashion a visual symbol with as definite a typological meaning as the symbols in early Italian painting, to an audience that no longer shared his transcendental assumptions, the goat appeared only as an image, an accurate representation of a natural fact that may or may not have some private significance to the artist. The *Athenaeum* review notes, "Of course, the salt may be sin, and the sea sorrow, and the clouds eternal rebukings of pride, and so on,—but we might spin these fancies from anything—from an old wall, a centaur's beard, or a green duck pond." In the example of *The Scapegoat*, the critic sees the central problem facing the Victorian artist after mid-century. Once natural fact is no longer seen figurally, no longer felt to have an inherent or "intrinsic" metaphysical correspondence to a specific spiritual fact, then any physical object can serve equally well to represent any general principle or emotional state and the way is open for the private mythologies and *symboliste* methods that characterize art and literature from the later nineteenth century to the present day.

1. 3 May 1856, p. 9.
2. Quoted in Staley, p. 68. Italics added.
3. No. 1489 (10 May 1856), p. 589.
4. N. s.2 (1 June 1856): 170.
5. *Times*, 5 May 1856, p. 5.

APPENDIX 1

No. 1.

My Sister's Sleep.

1

She fell asleep on Christmas Eve.
　Upon her eyes' most patient calms
　The lids were shut; her uplaid arms
Covered her bosom, I believe.

2

Our mother, who had leaned all day
　Over the bed from chime to chime,
　Then raised herself for the first time,
And as she sat her down, did pray.

3

Her little work-table was spread
　With work to finish. For the glare
　Made by her candle, she had care
To work some distance from the bed.

4

Without, there was a good moon up,
　Which left its shadows far within;
　The depth of light that it was in
Seemed hollow like an altar-cup.

5

Through the small room, with subtle sound
　Of flame, by vents the fireshine drove
　And reddened. In its dim alcove
The mirror shed a clearness round.

6

I had been sitting up some nights,
　And my tir'd mind felt weak and blank;
　Like a sharp strengthening wine, it drank
The stillness and the broken lights.

7

Silence was speaking at my side
　With an exceedingly clear voice:

[143]

I knew the calm as of a choice
Made in God for me, to abide.

8

I said, "Full knowledge does not grieve:
 This which upon my spirit dwells
 Perhaps would have been sorrow else:
But I am glad 'tis Christmas Eve."

9

Twelve struck. That sound, which all the years
 Hear in each hour, crept off; and then
 The ruffled silence spread again,
Like water that a pebble stirs.

10

Our mother rose from where she sat.
 Her needles, as she laid them down,
 Met lightly, and her silken gown
Settled: no other noise than that.

11

"Glory unto the Newly Born!"
 So, as said angels, she did say;
 Because we were in Christmas-day,
Though it would still be long till dawn.

12

She stood a moment with her hands
 Kept in each other, praying much;
 A moment that the soul may touch
But the heart only understands.

13

Almost unwittingly, my mind
 Repeated her words after her;
 Perhaps tho' my lips did not stir;
It was scarce thought, or cause assign'd.

14

Just then in the room over us
 There was a pushing back of chairs,
 As some who had sat unawares
So late, now heard the hour, and rose.

15

Anxious, with softly stepping haste,

[144]

Our mother went where Margaret lay,
 Fearing the sounds o'erhead—should they
Have broken her long-watched for rest!

<div align="center">16</div>

She stooped an instant, calm, and turned;
 But suddenly turned back again;
 And all her features seemed in pain
With woe, and her eyes gazed and yearned.

<div align="center">17</div>

For my part, I but hid my face,
 And held my breath, and spake no word:
 There was none spoken; but *I heard*
The silence for a little space.

<div align="center">18</div>

Our mother bowed herself and wept.
 And both my arms fell, and I said:
 "God knows I knew that she was dead."
And there, all white, my sister slept.

<div align="center">19</div>

Then kneeling, upon Christmas morn
 A little after twelve o'clock
 We said, ere the first quarter struck,
"Christ's blessing on the newly born!"

The Germ, No. 1.

APPENDIX 2

The Blessed Damozel.

1

The blessed Damozel leaned out
　　From the gold bar of Heaven:
Her blue grave eyes were deeper much
　　Than a deep water, even.
She had three lilies in her hand,
　　And the stars in her hair were seven.

2

Her robe, ungirt from clasp to hem,
　　No wrought flowers did adorn,
But a white rose of Mary's gift
　　On the neck meetly worn;
And her hair, lying down her back,
　　Was yellow like ripe corn.

3

Herseemed she scarce had been a day
　　One of God's choristers;
The wonder was not yet quite gone
　　From that still look of her's;
Albeit to them she left, her day
　　Had counted as ten years.

4

(To *one* it is ten years of years:
　　. Yet now, here, in this place
Surely she leaned o'er me,—her hair
　　Fell all about my face
Nothing: the Autumn-fall of leaves.
　　The whole year sets apace.)

5

It was the terrace of God's house
　　That she was standing on,—
By God built over the sheer depth
　　In which Space is begun;
So high, that looking downward thence,
　　She could scarce see the sun.

6

It lies from Heaven across the flood
　　Of ether, as a bridge.

[147]

Beneath, the tides of day and night
 With flame and blackness ridge
The void, as low as where this earth
 Spins like a fretful midge.

7

But in those tracts, with her, it was
 The peace of utter light
And silence. For no breeze may stir
 Along the steady flight
Of seraphim; no echo there,
 Beyond all depth or height.

8

Heard hardly, some of her new friends,
 Playing at holy games,
Spake, gentle-mouthed, among themselves,
 Their virginal chaste names;
And the souls, mounting up to God,
 Went by her like thin flames.

9

And still she bowed herself, and stooped
 Into the vast waste calm;
Till her bosom's pressure must have made
 The bar she leaned on warm,
And the lilies lay as if asleep
 Along her bended arm.

10

From the fixt lull of heaven, she saw
 Time, like a pulse, shake fierce
Through all the worlds. Her gaze still strove,
 In that steep gulph, to pierce
The swarm: and then she spake, as when
 The stars sang in their spheres.

11

"I wish that he were come to me,
 For he will come," she said.
"Have I not prayed in solemn heaven?
 On earth, has he not prayed?
Are not two prayers a perfect strength?
 And shall I feel afraid?

12

"When round his head the aureole clings,
 And he is clothed in white,

[148]

I'll take his hand, and go with him
 To the deep wells of light,
And we will step down as to a stream
 And bathe there in God's sight.

13

"We two will stand beside that shrine,
 Occult, withheld, untrod,
Whose lamps tremble continually
 With prayer sent up to God;
And where each need, revealed, expects
 Its patient period.

14

"We two will lie i' the shadow of
 That living mystic tree
Within whose secret growth the Dove
 Sometimes is felt to be,
While every leaf that His plumes touch
 Saith His name audibly.

15

"And I myself will teach to him—
 I myself, lying so,—
The songs I sing here; which his mouth
 Shall pause in, hushed and slow,
Finding some knowledge at each pause
 And some new thing to know."

16

(Alas! to *her* wise simple mind
 These things were all but known
Before: they trembled on her sense,—
 Her voice had caught their tone.
Alas for lonely Heaven! Alas
 For life wrung out alone!

17

Alas, and though the end were reached?
 Was *thy* part understood
Or borne in trust? And for her sake
 Shall this too be found good?—
May the close lips that knew not prayer
 Praise ever, though they would?)

18

"We two," she said, "will seek the groves
 Where the lady Mary is,

[149]

With her five handmaidens, whose names
 Are five sweet symphonies:—
Cecily, Gertrude, Magdalen,
 Margaret and Rosalys.

19

"Circle-wise sit they, with bound locks
 And bosoms covered;
Into the fine cloth, white like flame,
 Weaving the golden thread,
To fashion the birth-robes for them
 Who are just born, being dead.

20

"He shall fear, haply, and be dumb.
 Then I will lay my cheek
To his, and tell about our love,
 Not once abashed or weak:
And the dear Mother will approve
 My pride, and let me speak.

21

"Herself shall bring us, hand in hand,
 To Him round whom all souls
Kneel—the unnumber'd solemn heads
 Bowed with their aureoles:
And Angels, meeting us, shall sing
 To their citherns and citoles.

22

"There will I ask of Christ the Lord
 This much for him and me:—
To have more blessing than on earth
 In nowise; but to be
As then we were,—being as then
 At peace. Yea, verily.

23

"Yea, verily; when he is come
 We will do thus and thus:
Till this my vigil seem quite strange
 And almost fabulous;
We two will live at once, one life;
 And peace shall be with us."

24

She gazed, and listened, and then said,
 Less sad of speech than mild:

[150]

"All this is when he comes." She ceased:
 The light thrilled past her, filled
With Angels, in strong level lapse.
 Her eyes prayed, and she smiled.

25

(I saw her smile.) But soon their flight
 Was vague 'mid the poised spheres.
And then she cast her arms along
 The golden barriers,
And laid her face between her hands,
 And wept. (I heard her tears.)

The Germ, No. 2.

INDEX

References to page numbers of illustrations are given first in each entry in boldface type. References to individual works are listed under name of artist.

Index

Shop, 49–51; in PRB, 15, 49–50; in DGR, "My Sister's Sleep," 82; in JR, *Stones of Venice*, 30; subverted in JM, *Mariana*, 107; subverted in DGR, *Blessed Damosel*, 133

Jameson, Anna, 40

Keats, John: admired by PRB, 94; as source for HH, *Flight of Madeline*, 94; as source for *Isabella and the Pot of Basil*, 102; as source for JM, *Lorenzo and Isabella*, 99

Landscape: as erotic in DGR, *Blessed Damosel*, 133; moralized in HH, *Claudio and Isabella*, 112; moralized in JM, *Woodman's Daughter*, 105; as typical in HH, *Scapegoat*, 140
Lasinio, Carlo, *See* Gozzoli, Benozzo
Lindsay, Lord, 40.

Memling, Hans, and DGR, 81
Millais, John E.: on DGR illustration of *Faust*, 116; secular background of, 35; as *symboliste* painter, 113
—works:
Apple Blossoms, as *symboliste* painting, 113
Autumn Leaves, **115**, 113–15
Carpenter's Shop, The. See Christ in the House of His Parents
Christ in the House of His Parents, **48**, 47–56; and Academic art, 55–56; and Christian iconography, 49; and Collinson, "The Child Jesus," 56–58; contemporary response to, 51–52, 55–56; and genre painting, 55–56; and historicism, 47; and HH, *Converted British Family*, 71, 73–74; and JM, *Ophelia*, 108; and JM, *Woodman's Daughter*, 102; and scientific style, 47; as scriptural painting, 47; and DGR, *Blessed Damozel*, 130; and DGR, *Girlhood*, 62; and DGR, *Passover in the Holy Family*, 69; and typology, 49; and working class, 55–56; and JR, *Stones of Venice*, 30
Disentombment of Queen Matilda, The, **20**, 19

Dream of the Past, A: Sir Isumbras at the Ford, as *symboliste* art, 113
Eve of the Deluge, The, **100**, 99–101
Huguenot, on St. Bartholomew's Day, A, **78**, 77–79
Lorenzo and Isabella, **98**, 96–102; and TC, 105; and JM, *Mariana*, 105; and DGR illustration of *Faust*, 116; and JR 105
Mariana, **106**, 105–7; and JM, *Autumn Leaves*, 113; and JM, *Ophelia*, 108
Ophelia, **110**, 108
Order of Release, 1746, The, **80**, 79–81; and JM, *Huguenot*, 79; and JM, *St. Agnes Eve*, 107
Return of the dove to the Ark, The, **59**, 58–60
St. Agnes Eve, **109**, 107–8
Vale of Rest, The, as *symboliste* art, 113
Woodman's Daughter, The, **104**, 102–5
Morris, Jane, 131
Morris, William, 45, 55

Natural Theology: as model for artist, 3, 37; in JR, *Stones of Venice*, 28. *See also* Science, Pre-Darwinian
Nazarenes, and PRB, 44

Orchard, John, "Dialogue," 41

Paley, William, *Natural Theology*, 4
Pater, Walter: on Giorgione, 113; and JM, *Autumn Leaves*, 115
Patmore, Coventry: on DGR, *Passover in the Holy Family*, 67; as source for JM, *Woodman's Daughter*, 102
Poggioli, Renato, 45
Pre-Raphaelite artists (Italian). *See* Early-Italian artists
Pre-Raphaelite Brotherhood: and Academic art, 33, 40–42, 44–45, 54–56, 96; aesthetic of, 33–46; and aesthetic movement, 55; as avant-garde, 44, 55; and TC, 18, 24; dissolution of, xviii, 137; and early-Italian painters, 44–45; founding of,

Index

Pre-Raphaelite Brotherhood (*continued*) xvii, 33, 52, 94; history painting, 10, 34, 41–44, 47, 71–91; model of art history, 41, 45; and modernism, xvi, 44–45; literary painting, 15, 93–136; moralization of genre painting, 10, 85; and William Morris, 55; name, use of, 60, 62; name, significance of, 40, 51–52; and Nazarenes, 44; and Pre-Raphaelite movement, xviii; and primitivism, 54; as religious artists, xvi–xvii, 10–11, 33, 38, 41–42, 44, 47–70; as scientists, 15, 34–37; scriptural painting, 47–70, 94, 137–39; and A. C. Swinburne, 55; and tradition, 34, 44–45

Pre-Raphaelite, Victorian definition of, 62

Primitivism, and PRB, 54.

Raphael: PRB view of, 33, 40–41, 54; JR view of, 33

Raphaelite style. *See* Academic art.

Realism: in TC theory, 7; and PRB, 38, 40–42, 93; in JR theory, 7; in PRB scriptural painting, 42–44; as symbolic, xvii

Religious science. *See* Science, Pre-Darwinian

Rossetti, Christina, "The P.R.B.," 105, 137

Rossetti, Dante Gabriel: and aesthetic movement, 55; and Dante, 35, 121–31, 135–36; on early-Italian painters, 41; and Flemish painters, 81; later style of, xviii, 115–16, 128; literary painting by, 115–18; and Raphaelite style, 41, 60; scriptural painting by, 33, 60–69, 121, 137; Tractarian background of, 34

—works:

"Ave," 65–67, 82

Beata Beatrix, **134,** 128, 135–36

Beatrice Meeting Dante at a Marriage Feast, **125,** 126

"Blessed Damozel, The," (poem), 130–36; and JM, *Lorenzo and Isabella*, 102

"Blessed Damozel, The," (study for), **132,** 131

Blessed Damozel, The (painting), 135

Ecce Ancilla Domini!, **64,** 63–65, 102, 121, 131

Faust: Gretchen and Mephistopheles in the Church, **117,** 116–18

Faust with Skeletal Death, 116

First Anniversary of the Death of Beatrice, The (1849), **124,** 123–26, 128, 135

First Anniversary of the Death of Beatrice, The (1853), **129,** 128–30

Found, **86,** 10, 22, 85–87

Giotto Painting the Portrait of Dante, **127,** 126–28

Girlhood of Mary Virgin, The, **61,** 60–63, 82, 116, 121, 123, 130–31; and attached sonnets, 63, 65

" 'Hist!' Said Kate the Queen," **120,** 118–21

Laboratory, The, **119,** 118

Maries at the Foot of the Cross, The, 65

Mary in the House of St. John, 67

Mary Nazarene, 67

"Mater Pulchrae Delectionis," 65

Mephistopheles outside Gretchen's Cell, 116

"My Sister's Sleep," 82–85; and JM, *Mariana*, 107; and DGR, "Blessed Damozel," 130–31; and DGR, *The First Anniversary* (1849), 126; and DGR, *Found*, 87

Passover in the Holy Family, The, 67

Passover in the Holy Family, The (design for), **68,** 67–69, 126

"St. Luke the Painter," 41

Salutation of Beatrice, The (study for), **122,** 121–23, 135

Seed of David, The, **83;** and "My Sister's Sleep," 82

"Songs of the Art Catholic," 65

"Venetian Pastoral, by Giogione; in the Louvre, A," 113

Virgin Mary Being Comforted, The, 65

Rossetti, William Michael: on HH, *Claudio and Isabella*, 108, 112; on HH, *Hireling Shepherd*, 89; on HH, *Scapegoat*, 139–40; on JM, *Autumn Leaves*,